Pacific
Art IN DETAIL

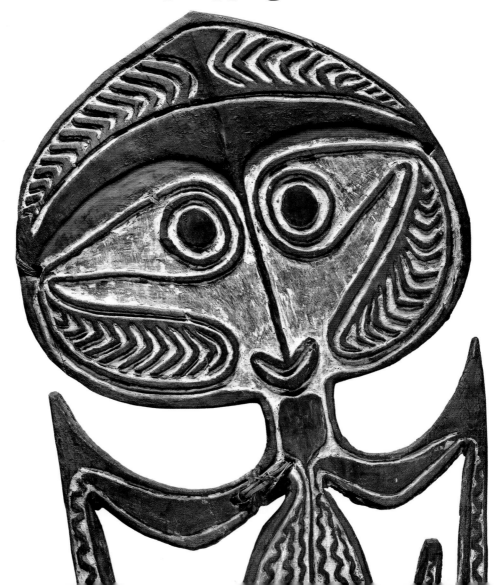

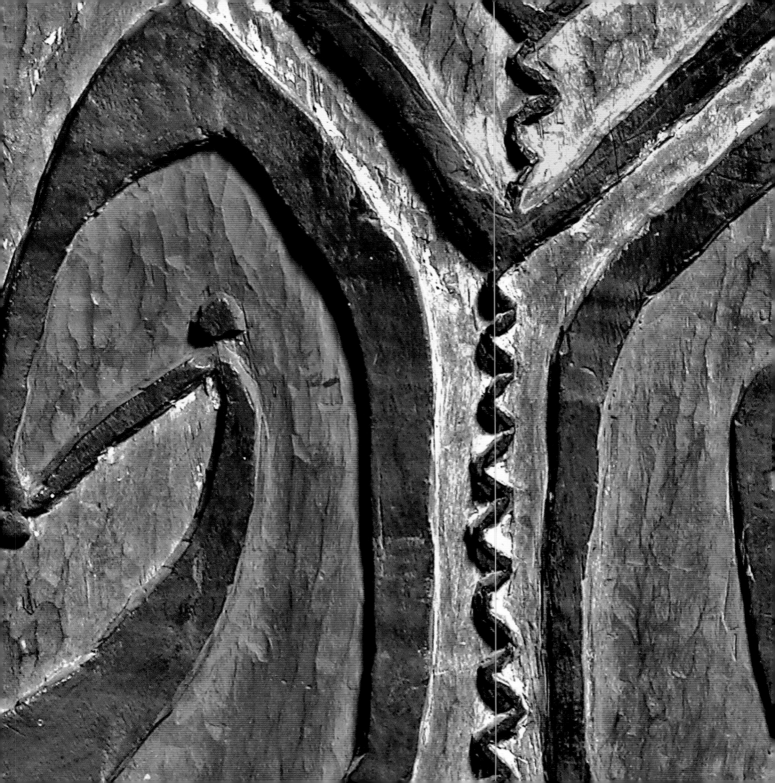

Pacific
Art IN DETAIL

Jenny Newell

THE BRITISH MUSEUM PRESS

HALF-TITLE PAGE: Detail from a skull rack (*agibe*). Gulf Province, Papua New Guinea, before 1904. Wood, rattan, vegetable fibre. H. 117 cm. W. 49.5 cm. D. 4.5 cm (see p. 52).

FRONTISPIECE: Detail from a painted shield, with ornament in carved relief. West Papua, before 1927. Wood, pigment. H. 144 cm. W. 40 cm.

RIGHT: Detail from a printed fabric sample, with pattern of hibiscus flowers. Imported from China by Shantilal Brothers Ltd. Suva, Fiji. 2000–05. Cotton. L. 106 cm. W. 33 cm.

© 2011 The Trustees of the British Museum

First published in 2011 by The British Museum Press
A division of The British Museum Company Ltd
38 Russell Square, London WC1B 3QQ
www.britishmuseum.org

A catalogue record for this book is available
from the British Library

ISBN 978-0-7141-2590-9

Photography by the British Museum Department of Photography and Imaging. All of the images featured in this book are © The Trustees of the British Museum, unless otherwise stated in the accompanying captions.

Designed and typeset in Minion and Helvetica by Peter Ward
Printed by C&C Offset Printing Co., Ltd, China

The papers used in this book are natural, renewable and recyclable products and the manufacturing processes are expected to conform to the environmental regulations of the country of origin.

Contents

Preface

The arts of the Pacific are magnificently diverse. With more than 10,000 inhabited islands, the Pacific ocean is probably the world's most culturally diverse region. Past Pacific artists created objects that centred on managing the power of people and deities, land and sea, spirits and ancestors; contemporary artists explore the changing world, engaging with local and global art practice. Showcasing treasures, both old and new, from the extraordinary Oceania collection at the British Museum, this book provides an enlightening view into the diversity of the Pacific region.

The Oceania collection at the British Museum is one of the world's most significant collections from the Pacific, encompassing around 37,000 items and stretching from 11,000-year-old archaeological finds to contemporary paintings and sculpture. The collection includes works in wood, stone, bone, textiles, ceramics, feathers, dog fur, shell, coconut shell, plastic, metal and more. These works were made and collected across the breadth of Oceania, a region comprising the Pacific Islands, including Aotearoa (New Zealand) and Australia and the Torres Strait.

Some of the collection is on display in the Museum itself, and researchers, artists and members of source communities visit the artefacts in the reserve collection. They are more widely accessible through publications and online resources.

More can be discovered about the objects of art in this book through the British Museum's Collection Database on the Museum's website. This database can be searched using a relevant search term or the object's registration number (see page 143).

This book is for everyone interested in finding out more about the arts of the Pacific. While the objects shown here are all at the British Museum, they are representative of the types still being made by Pacific Islanders and found in historic collections in private and public institutions around the world. A list of institutions with significant Pacific collections is included on page 141.

In recent decades Pacific Islanders have been increasingly engaged with museum objects, historic photographic collections, and archives as documents of the art forms and techniques of their ancestors. This is part of a broader process of rediscovering traditional

methods and reinvigorating early art practices. As the artist and scholar Rosanna Raymond has said, museums can become 'arenas for cultural exchange, going outside the boundary of the space into everyday life' (2008).

ACKNOWLEDGEMENTS

I thank the team at British Museum Press: Naomi Waters, Axelle Russo, Nina Shandloff (original editor of the series), Rosemary Bradley, and particularly my excellent editor, Emma Poulter for bringing the book together so well. Heartfelt thanks to Michael Row of the British Museum's Photographic and Imaging Department for making these often very challenging objects look their best and also to Peter Ward for designing the striking layouts and being superbly accommodating of the demands of an international collaboration carried out by email. I am grateful to my former colleagues in the Museum's Oceanic department for all their insights and advice and the pleasure of working together over many years: Lissant Bolton, Jill Hasell, Natasha McKinney, Elizabeth Bonshek, Julie Adams and Ben Burt. Particular thanks to Eric Kjellgren for lending his comprehensive expertise to improving the manuscript and to Nicholas Thomas, Kalissa Alexeyeff, Anna Edmundson and Adrienne Kaeppler for their valuable contributions to the project. Many thanks to fellow researchers Kylie Moloney and Rachel Eggleton for being such generous friends to the book and me. I appreciate contributions of insights, edits and images from a wide range of Pacific curators, artists and scholars: Victoria Barnecutt, Joshua Bell, Sagale Buadromo, M. Kamalu duPreez, Michael Gunn, Sabine Hess, Tara Hiquily, Steven Hooper, Crispin Howarth, Cris Lindborg, Kolokesa and'Okusitino Māhina, So'ona'alofa Sina Malietoa, Sean Mallon, Jean Tekura Mason, Olympia E. Morei, Vèronique Mu-Liepmann, George Nuku, Tahiarii Yoram Pariente, John Pule, Ralph Regenvanu, Paul Tapsell, Rosanna Raymond, Tumata Robinson, Dirk Spennemann, Emma Tamari'i, Michel and Jayne Tuffery, Jo Anne Van Tilburg, Mainifo Viliamu.

The National Museum of Australia, Canberra, generously supported the writing of this book during my fellowship at the Centre for Historical Research. Special thanks go to Peter Stanley, Director of the Centre, for his ever-enthusiastic support, and to Anne Faris. I very cleverly have Mark Gunning as my husband, who is willing to provide late night design advice, create fabulous maps and patiently supply comprehensive support from computer wrangling to small boy care. I am deeply grateful. I dedicate the book to my dear three: Mark, Ben and Tom.

1

What is Pacific Art?

'Visual culture reminds us of what's carried in our minds…Maybe objects can be the windows through which our cultures can see each other and communicate.'

Michael Mel, artist and academic, Papua New Guinea, 2009

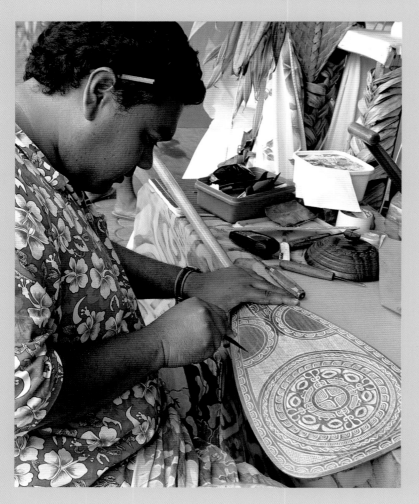

The arts of the Pacific Ocean's many cultures are dazzling in their richness. Some of these arts are easily recognized: from the majestic stone ancestor figures of Rapa Nui (Easter Island), to the spectacular feather headdresses of Papua New Guinea. Closer and more detailed examination allows us deeper understanding of these arts.

The people of the Pacific have always created powerful things. Carvings, textiles and architecture, as well as dance, oratory and other performing arts, are all visually potent and have often been about managing the flow of power through people and the land. Many of these works have acted to provide a connection to gods, spirits and ancestors – and attempt to manage their impact on the living. The visual impact of an object – its stunning intricacy, its beautifully formed simplicity or its aggressive potency – is central to the object's power.

As you will see in these pages, Pacific Islander artists today often intersect their work with traditional forms. Some are inspired by the carved canoes and meeting houses, the ceremonial masks and dance costumes, kites, feather cloaks, and weapons of earlier eras, and either re-create or work from a basis of these forms. Many artists of the contemporary Pacific are also creating new art forms that

comment on today's world, from sculptural installations combining found objects and photography to performance pieces for a digital environment.

This book presents on an intimate scale a view into the creativity of this dynamic region: its people, places and productions.

The Pacific Ocean covers one-third of the globe and contains more than 25,000 islands. Depending on where one draws the boundaries, the number of inhabited islands can be said to be about 10,000. Each island group has its distinctive arts, as well as distinctive topographies, cosmologies, societies, polities and economies. Nevertheless, within this diversity, the Pacific is still a region bound together by its connecting ocean and connected histories, with ongoing cultural links between the islands. While there are many smaller regional identities, most islanders of the Pacific Ocean recognize a degree of shared heritage and shared identity.

There are approaches to life that can be seen to be embodied in the arts across the great breadth of the Pacific. There are common approaches to the world that have a long history, but still retain validity: the deep-running, potent connections to land, to sea and to family, ancestors and sacred beings. These connections find expression in the things that Pacific Islanders make. The chapters in this book reflect these important streams within Pacific Island life.

Art has generally been defined by Pacific Islanders over time as something that is carried out with skill – something well made or well performed. One of the skills valued has been 'indirectness': the ability to conceal effectively the meanings of things in layers, which are sometimes gradually, but not always completely, revealed. Gender has been a key line of division in Pacific cultures. Historically, most activities were assigned to either men or women: men were carvers, tattooists and canoe builders. Women were the makers of barkcloth (*tapa*), potters, plaiters of mats and canoe sails. While many of these divisions in art practice have dissolved, they do continue in some Pacific cultures.

LEFT:
Joel Roõtuehine, Marquesan arts festival, Pape'ete, Tahiti, November 2003. Photo: author.

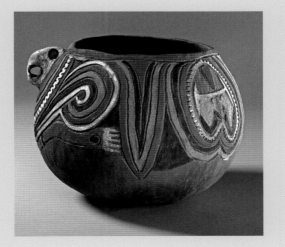

Kwam (serving bowl). Sarikim village, Wosera people, East Sepik Province, Papua New Guinea. c.1980. Clay, pigment. H. 18 cm. Di. 24 cm. These bowls are made by women and painted by men. This one was collected at the same time as the figure on page 76.

Pacific-wide, artists have historically worked with the stuff of sacredness. The things they made channelled the flow of a sacred power, often given the term *mana*. This power flows from the most sacred of founding gods or ancestors down through descendants, and must be managed carefully. A strong, successful leader or a great war canoe has substantial *mana*; contact with both of these must be managed carefully, to avoid damage. Things and activities that are sacred and restricted are *tapu* (a word that, brought back to England by explorer and navigator Captain James Cook, became 'taboo'). Carving and tattooing, in many parts of the Pacific, have traditionally been considered *tapu* activities.

On many of the Pacific's islands, the continuity of cultural traditions was eroded or broken in the 1800s and early 1900s through the actions of missionaries, traders and colonial authorities. Europeans had started travelling through the Pacific from the 1500s, and visiting, trading and settling in the Pacific in significant numbers from the 1770s. After a few decades European nations began forcibly taking land. Bans on traditional practices and the arrival of new materials and techniques had a profound impact.

A mainstay of creative practice in the Pacific, however, has been the ability of artists to adapt and explore change while maintaining a hold on traditions. Islanders have a long history of innovations inspired by new things and ideas from beyond their borders. When Europeans and islanders started encountering each other in a sustained way, they were often captivated by each other's material creations. Their exchanges – giving gifts, trading – were mutually enthusiastic.

In Europe, accounts of Pacific peoples augmented by the evidence in objects brought back by voyagers, stimulated debates about the nature of human society. There was a keen audience for the material culture of the Pacific in museums, private collections and the engraved illustrations in travel accounts, inspiring theatrical productions, garden design and a market for publications. Enthusiasm waned later in the 1800s, particularly as the romantic appeal of Pacific Island cultures was seen to have dimmed, changed by the introductions from Western societies: the Church, colonial rule and manufactured goods. France, Britain, Spain, Germany, the United States, Japan and Australia all established colonies in the region. Tourism to the region from the early 1900s recast the Pacific as a leisure paradise. This has been a persistent vision.

RIGHT: **Map of the Pacific region.**
© Mark Gunning. www.gunningdesign.com.

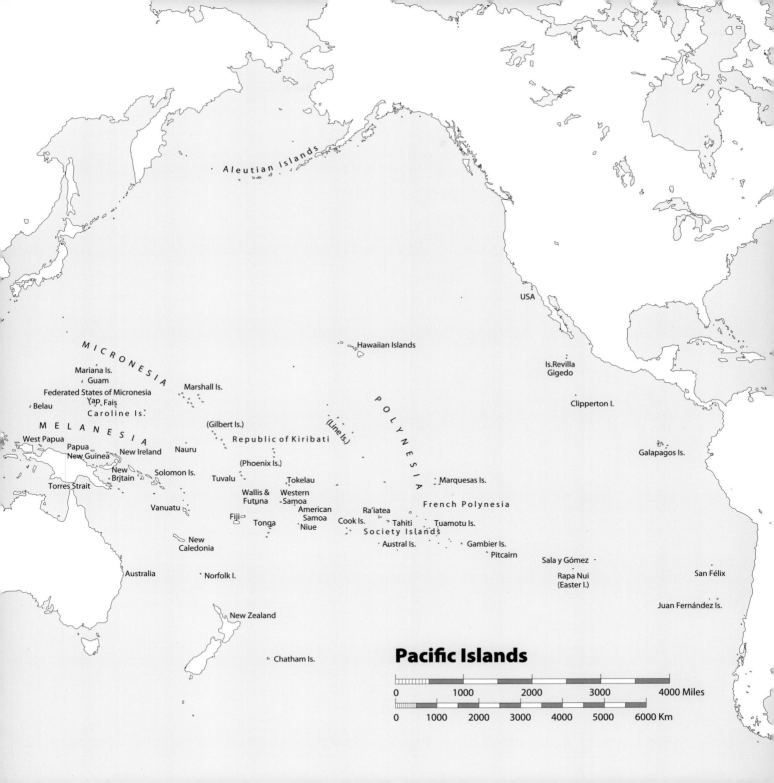

Aleutian Islands

USA

MICRONESIA

Hawaiian Islands

Mariana Is.
Guam
Marshall Is.
Federated States of Micronesia
Yap Fais
Belau
Caroline Is.

Is.Revilla
Gigedo

POLYNESIA

Clipperton I.

MELANESIA

(Gilbert Is.)
(Line Is.)

West Papua
Papua
New Guinea
New Ireland
Nauru
Republic of Kiribati

Galapagos Is.

New
Brjtain
Solomon Is.
Tuvalu
(Phoenix Is.)

Torres Strait
Wallis &
Futuna
Tokelau
Western
Samoa
Marquesas Is.

Vanuatu
Fiji
Tonga
American
Samoa
Niue
Raʻiatea
French Polynesia

Cook Is.
Tahiti
Tuamotu Is.

New
Caledonia
Society Islands

Austral Is.
Gambier Is.

Pitcairn

Sala y Gómez

Australia
Norfolk I.
Rapa Nui
(Easter I.)
San Félix

Juan Fernández Is.

New Zealand

Chatham Is.

Pacific Islands

| 0 | 1000 | 2000 | 3000 | 4000 Miles |

| 0 | 1000 | 2000 | 3000 | 4000 | 5000 | 6000 Km |

Pacific arts at the British Museum

The British Museum's relationship with Oceania began when a staff member, Daniel Solander, accompanied Captain James Cook on his first voyage to the Pacific Ocean in 1768. The material from these voyages was displayed in the Museum's South Seas Room from about 1778. It proved to be one of most popular rooms in the Museum.

Thereafter Oceanic material was shown in ethnographic galleries. The mourners' costume from Tahiti (page 70) was on display in the Museum from the end of the 1700s for well over 100 years. In recent decades the Museum has presented exhibitions such as *Māori* (1998), *Power and Taboo: Sacred Objects from the Pacific* (2006–07), and the 2009 show *Dazzling the Enemy: Shields from the Pacific*. Staff at the Museum collaborate

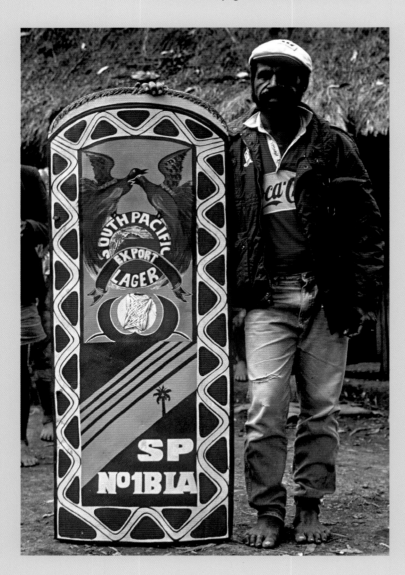

Kaipel Ka with one of his painted war shields, Wahgi people, Western Highlands Province, Papua New Guinea. Purchased for the British Museum in 1990. Photo: Michael O'Hanlon, Pitt Rivers Museum, Oxford.

With an eye to global and local brands, comic-book heroes and traditional designs, Kaipel Ka (*c*.1950–2008) painted shields for use in inter-group fighting from the mid-1980s. This shield features the logo for South Pacific Lager as a unifying 'team' image for the Baiman, a sub-group of the Senglap tribe. As Kaipel Ka explained, 'beer was at the root of the war', after a road death involving a drunk man. A British Museum curator bought a set of these shields while on fieldwork with the Wahgi. When exhibited at the Museum in 1993, they arrested attention and have since been published and displayed around the world.

with Pacific communities on joint projects and from time to time are able to liaise with an artist to acquire an artwork. Unlike many of the historic collections, these contemporary works are thoroughly documented – and well placed to enhance our understanding of the complexities of modern life in the Pacific.

While the British Museum holds a rich Australian collection, this book focuses on the Pacific Islands, rather than the broader reach of Oceania. Apart from the painting below, arts of indigenous Australia are not included here. Aboriginal Australians trace a separate cultural lineage to Pacific peoples. The book, however, includes two works from the Torres Strait Islands because, while these islands are politically part of Australia, they are culturally more aligned to Melanesia.

George Nuku at the blessing of the Māori meeting house display, featuring historic *taonga* and Nuku's contemporary works in Perspex. 'Living and Dying' exhibition, British Museum, 2009.

Victor Jupurrula Ross, *Yarla Jukurrpa* ('Bush Potato Dreaming'). Yuendemu, Northern Territory, Australia, 1980s. Acrylic on canvas. H. 106 cm. W. 159 cm.
The British Museum's Australian collection contains both historic material and contemporary works such as this.

13

What are Polynesia, Melanesia and Micronesia?

Since the 1830s the Pacific Ocean has been divided by Westerners – and to some extent by Pacific peoples themselves – into three cultural-geographical regions. These are Polynesia ('many islands'), Melanesia ('black islands') and Micronesia ('small islands'). The original definitions were based on racial explanations for the cultural cohesion that Europeans were identifying. This explanation has been superseded, but the cultural distinctions remain valid, reflecting similarities in languages, social, political and religious structures, economic life, and approaches to arts. Polynesia is the largest region, covering the eastern Pacific and much of the central and southern ocean. The 'Polynesian triangle' from Rapa Nui (Easter Island), up to Hawai'i and down to Aotearoa (New Zealand) includes islands such as Tahiti, the Marquesas, Cook Islands, Tonga and Samoa (see glossary for a fuller listing). Melanesia lies in the western Pacific, including the major islands and archipelagos of New Guinea, New Britain, New Ireland, the Solomon Islands, Vanuatu and New Caledonia.

Micronesia is made up of more than 2,000 islands and atolls in the northwest Pacific, including Belau (Palau), Mariana Islands, Federated States of Micronesia, the Caroline Islands, Marshall Islands, and Kiribati.

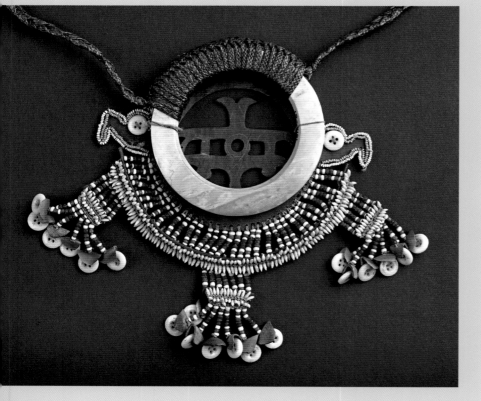

**Chief's shell-money (*bakiha*) pendant.
New Georgia or Isabel, Solomon Islands (Melanesia), before 1914.
Turtle shell, dolphin's teeth, tridacna shell, glass beads, fibre, buttons. W. 21 cm.**
Important men in the New Georgia group and Isabel Island used to wear high-status *bakiha* money-rings, ornamented as pendants.

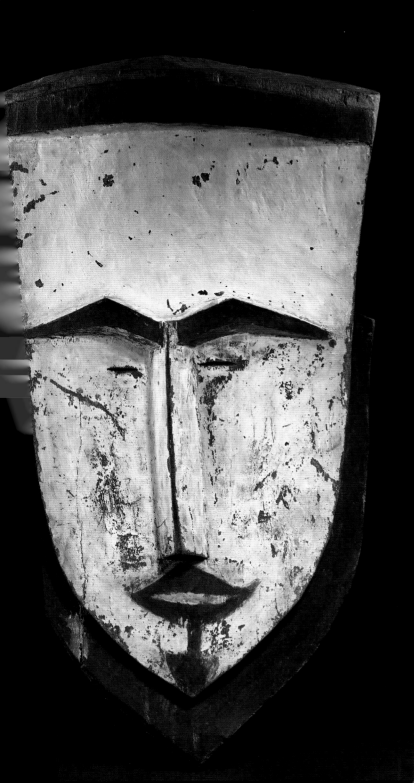

Pacific Islanders often use these terms, but as with any classification – especially one devised by outsiders – Polynesia, Melanesia and Micronesia are useful for some purposes, but are also politically problematic and often fail to reflect realities on the ground. There is a growing preference for the term 'Oceania' to speak of all the Pacific Islands, to highlight the unified strength of the region, and to find more meaningful classifications. Simple geographic divisions – central and eastern, western and northwestern – are good alternatives and the divisions that I primarily use in this book.

I hope that you enjoy this journey into the arts of the Pacific.

Mask of a deified ancestor.
Satawan Atoll, Mortlock Island,
Caroline Islands (Micronesia).
Breadfruit wood, coconut fibre, pigment.
H. 67 cm. W. 36.6 cm. D. 24 cm.
This mask was danced in ceremonies to encourage good breadfruit harvests.

2

Art of the Moment

'I'm the next generation. I feel I've done my homework, and can interpret things differently.'

New Zealand-based printmaker, painter and sculptor Michel Tuffery, 1997

Dance of the culture hero Qet, featuring an aeroplane headdress. Vanua Lava, Vanuatu, 2003. Photo: Sabine Hess. In a blend of traditions, this dance was performed on Christmas day, with an Anglican priest as master of ceremonies.

Pacific arts are always changing. This chapter presents a selection of contemporary artworks. Each of them draws on a foundation of old ways of relating to the world and brings new approaches, new media and new techniques into play. These works respond to and comment on the contemporary world.

Today, one in nine Pacific Islanders lives abroad. There is a vibrant artistic diaspora – Pacific Islander artists work all around the world. There are particular creative hubs in Los Angeles, San Francisco, London and Paris. Within Oceania, Auckland, Wellington and Sydney are particularly active centres for artists from across the breadth of the Pacific.

Pacific art festivals bring visual artists, dancers, fashion designers, sculptors, tattoo artists and others from across the region. The largest, the Festival of Pacific Arts, is hosted every four years by a different nation. Since the first festival in 1972, national delegates have been contributing to competitions, displays and the vibrant exchange of ideas. Regional festivals, such as the Melanesian Arts Festival, have worked to create a sense of shared regional identity, as well as a clearer definition of subregional traditions. Arts festivals in countries on the borders of the Pacific, most notably the Queensland Art Gallery's Asia-Pacific Triennial of Contemporary Art (APT) have been providing vibrant forums in which Oceanic artists intersect with other artists and audiences from beyond the Pacific.

The conversation between traditional and modern approaches has tended to be more troubled in Oceania than in the West. Oceanic artists can feel more closely defined – whether they would like to be or not – by their cultural background. Audiences and practitioners in Pacific Island nations sometimes carry expectations that art will preserve and continue to lend validity to local cultural traditions. This is the case particularly when those traditions are seen to be under threat from Western influences. Thus, artists who use images, styles or materials from other cultures can meet with opposition from their own communities. Michel Tuffery's works (see right and chapter 9) have drawn critique from elders who value functional arts and feel that the 'art for art's sake' model is frivolous. But there is no

Michel Tuffery, untitled, 2007. Photographer: Gareth Moon (Nektar Films), Wellington). Collection of the artist.

This work is based on studio images taken as Tuffery was developing his 'First Contact' series (see page 125).

easy consensus on what exactly is 'authentic' or 'historical' either. As Anne D'Alleva, a Pacific art historian, has said: 'the past is as multifaceted and open to interpretation as the present, and tradition is not fixed but contested' (1998).

There is a strong history across the Pacific, as in most art traditions, of innovating and responding to changing conditions. Whether responding to new spiritual or ceremonial requirements, shifting political situations, or the availability of imported media and imagery significant to modern life, Pacific artists have embraced the new. This is explored more fully in the book's final chapter.

Experimentation has continued in all creative forms throughout the Pacific. Today, artists use painting, printmaking, textiles, sculpture, installations, multimedia and more, with materials and techniques drawn from artistic traditions both local and international.

George Nuku's meeting-house panels in the British Museum's *Living and Dying* exhibition, for example (see page 13), work to unify the disparate historic carved wooden panels in the display about the Māori *wharenui* (meeting house). Nuku, who celebrates his combined Māori and Scottish heritage, has carved historically accurate panels – from Perspex (see page 13).

**Ralph Regenvanu, *The Melanesia Project*.
The Melanesian Arts Project, London, 2006.
Acrylic on canvas. W. 100 cm. H. 50 cm.**

'The painting is about aspects of my cultural
heritage that are no longer available in my own
community, but are available overseas, particularly
in London.'
(Ralph Regenvanu, May 2006)

Today, many Pacific Islander artists work both
in and beyond the Pacific, part of a large artistic
diaspora. In this painting, the British Museum
stands in contrast and connection with the artist's
ceremonial clan ground (*nasara*) in Uripiv, Vanuatu.
Regenvanu, a major figure in Vanuatu's cultural

and political establishments, painted this work
while on a residency at the British Museum in
2006 as part of the Melanesian Arts Project, which
worked to connect collections at the Museum
with people in the western Pacific. Three of the
Museum's Pacific objects are visible on the portico:
a figure and slit gong from Vanuatu, and the
Rapa Nui *moai* (see page 66). These are shown
physically and historically separated from Vanuatu,
a disconnection indicated by the red and yellow
bands. However, the succession of circles ending
with a double crescent-moon indicates a path of
connectivity. Regenvanu found this moon design at
the Museum on a headdress. Through this painting
he is repatriating the design.

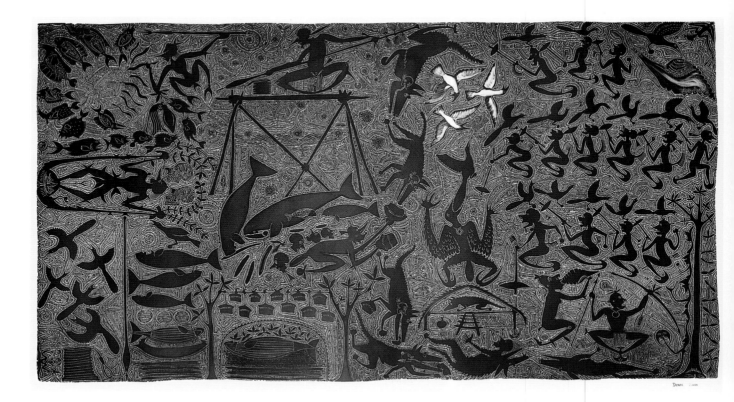

Dennis Nona, *Sesserae (Badu Island Story)*.
Badu Island, Torres Strait Islands, 2004–05.
Hand-coloured linocut on paper. W. 200 cm.
H. 112 cm.

Dennis Nona uses contemporary printmaking
to bring old legends to a new audience. As a
boy on Badu Island in the Torres Strait (between
Australia and Papua New Guinea), Nona learned
the intricacies of traditional carving. He later
applied these techniques to linocutting. His
images are vibrant retellings of complex stories,
sung and danced through the generations,
and his award-winning artworks are exhibited
around the world.

Here, in this large print (two metres wide),
Nona depicts a Wakaid clan story of a young
man, Sesserae, who learns from the spirits of his
parents how to capture and cook the *dugong*, a
marine mammal. Sesserae starts hunting from
a stage set out over the water, and the dugongs
are then cooked and smoked. On the right-hand
side, members of neighbouring clans pursue
Sesserae for this knowledge. But he will not
share it. To escape attack, he turns himself into
the cunning willy wagtail bird (a species native to
the Torres Strait and surrounding regions) flying
low over the heads of the warriors.

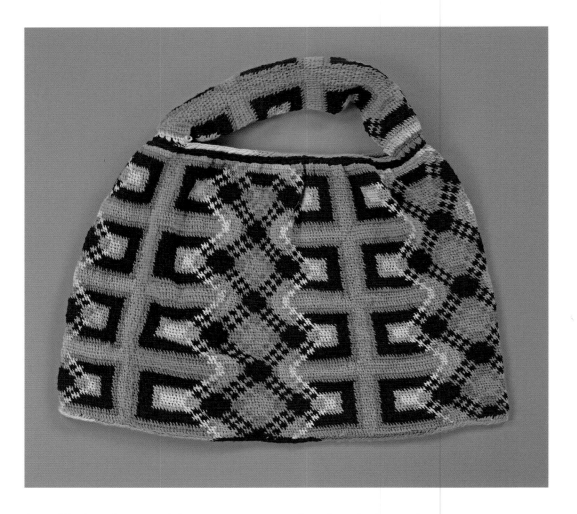

Joyce Kinshap, *Computer bilum*.
Western Highlands Province, Papua
New Guinea, 2007.
Acrylic yarn. L. 53.4 cm. W. 34.7 cm.

This bag, by Joyce Kinshap, features a design of computer monitors and the Internet network between them. Women in the highland areas of Papua New Guinea have long made string bags (*bilum*) in striking, individualized designs. Using hand-spun plant fibre or acrylic yarn, they finger-loop the string in complex patterns to create a stretchy, knotless netting. *Women use bilum like handbags and those with longer handles for carrying food, goods and babies.* Kinshap made this bag in her village, Mundika, in the Western Highlands Province, using trade-store yarn. It is a reminder of how networks of information and trade are increasingly linking the Pacific's inland villages – as well as busy, urban centres – to the broader world.

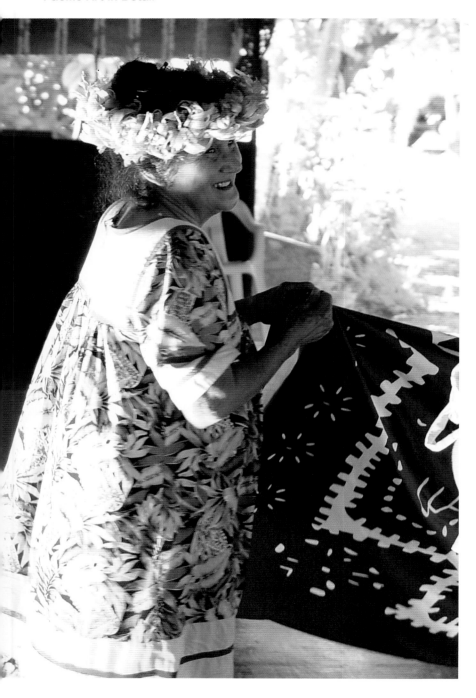

RIGHT: **Emma Tamari'i**, *tifaifai* (quilt), 'eventail' (fan) design. Pape'ete, Tahiti, 2002–03. Cotton. L. 251 cm. W. 230 cm.
LEFT: **Emma Tamari'i with her 'eventail'** *tifaifai*. Tiparui, Tahiti, 2003. Photo: Mark Gunning.

Emma Tamari'i has finely appliquéd this striking quilt with a multi-symmetrical design of fans. Women of Tahiti, the Cook Islands and Hawai'i have been making quilts since the 1800s. Missionary women introduced sewing as a morally approved occupation for island women. It was not long before island women were sewing designs to suit themselves, using imagery of bright tropical fruits, flowers and everyday objects of significance. As women in Polynesia started to make barkcloth (*tapa*) less, quilting took over some of the social roles that had surrounded *tapa*. Like *tapa*, quilts are often made by women together – as this one was, with Emma's daughter assisting. They have also been used in similar ways to *tapa* – in the home or as a precious gift.

Today, sewing *tifaifai* in Tahiti (*tivaivai* in the Cook Islands) is an important mode of expression and income for women. National competitions foster quality and innovation. Tamari'i's work has sparked a new genre that uses intricate fine cuts in the cloth, inspired by the detailed carving of her home islands, the Marquesas. Tamari'i sold this *tifaifai* to a visiting curator at an artisan's cooperative near Pape'ete in 2003.

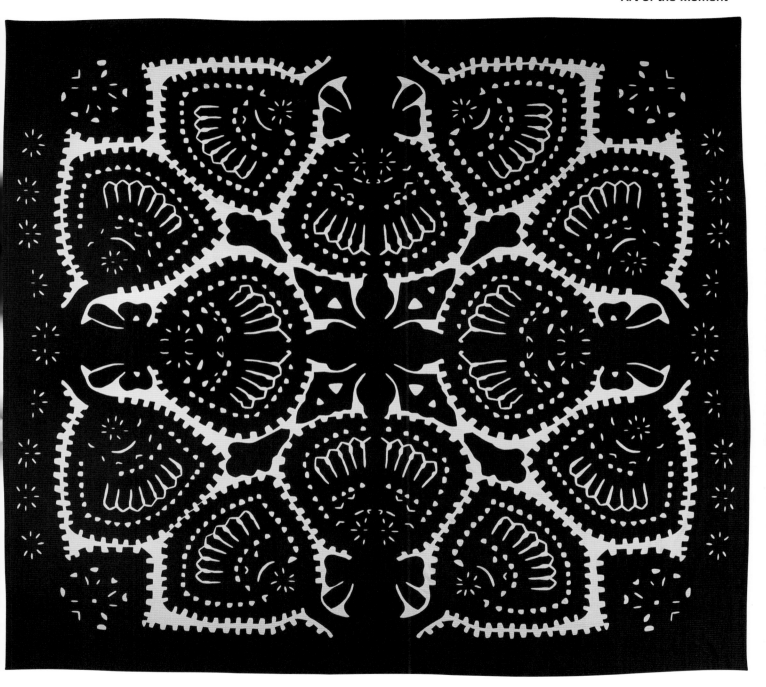

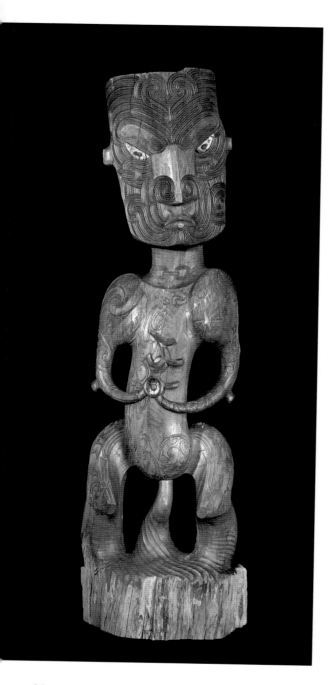

Lyonel Grant, 'Te Māori', Treaty of Waitangi carving.
Aotearoa (New Zealand), 1997.
Wood, *Haliotis* (*paua*) shell. H. 264 cm. W. 79.5 cm. D. 35.5 cm.
Lyonel Grant's towering figure is powerfully linked to the land of Aotearoa (New Zealand). Standing more than 2.6 metres tall, he gazes down at the viewer. His relationship to the land is made clear, connected through his umbilicus. He is marked with the tattooed signs of its clan.

The figure makes a strong political statement, with the words '1840 Waitangi' borne on his shoulder and a chain around his neck. The Treaty of Waitangi, brokered between the British colonial government and Māori chiefs in 1840, was signed on the basis of a misleading translation, giving the chiefs a false assurance that they would maintain ownership of their land. The Treaty ultimately transferred authority to Britain. The conflicts arising from this have been bloody and the discontent long-lasting. Forming the basis of the nation's constitutional and legal frameworks, the Treaty of Waitangi remains central to relations between Pākehā (white settlers) and Māori.

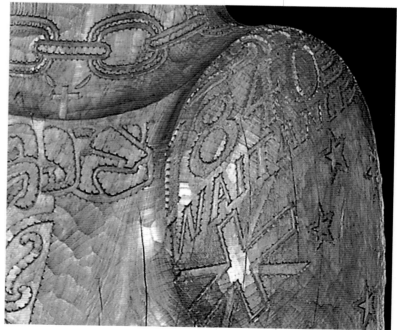

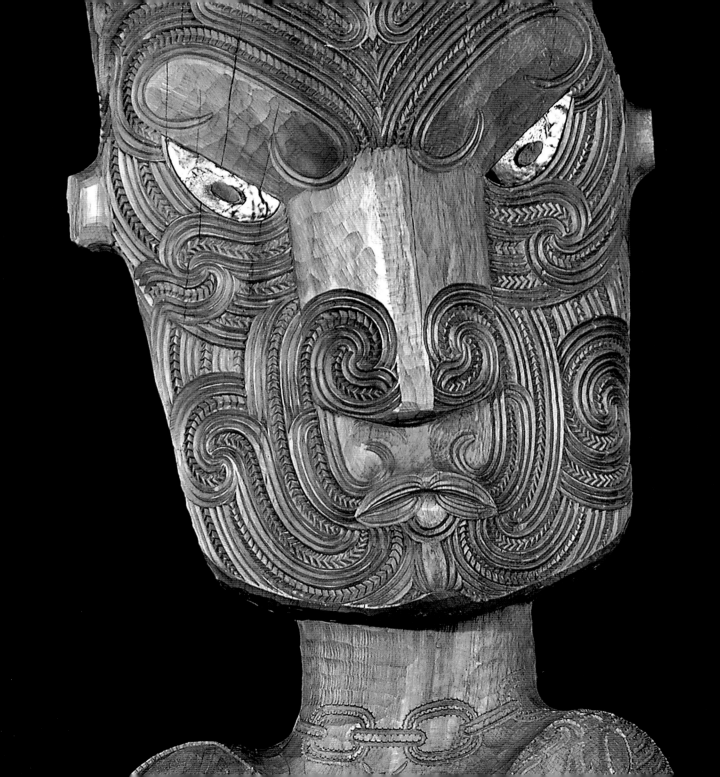

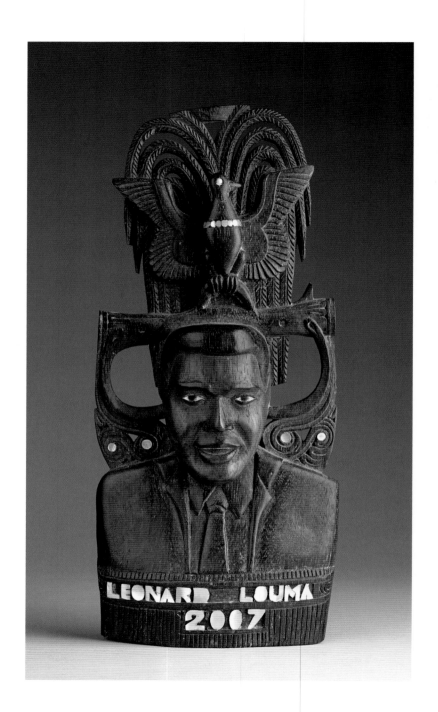

Isaak Saluwai election plaque.
Kiriwina, Trobriand Islands, 2007.
Wood, *Haliotis* (paua) shell. H. 32.5 cm.
W. 14 cm. D. 4.3 cm.

Carving is a prominent art form in Kiriwina. The island is in the Trobriand chain, politically part of Papua New Guinea. In the 2007 Kiriwina elections, Isaak Saluwai carved this plaque to support a local candidate, his clansman Leonard Louma. Saluwai displayed it at his house, to show his support. With the glittering shell inlay and tightly curving scrolls typical of the Trobriands (see the canoe splashboard on pages 42–3), the plaque speaks of the candidate's nationalistic agenda. A bird of paradise, Papua New Guinea's national emblem, is above him. It perches on another emblem, the traditional *kundu* drum. Saluwai sold the plaque to a visiting British Museum curator when Louma lost the election.

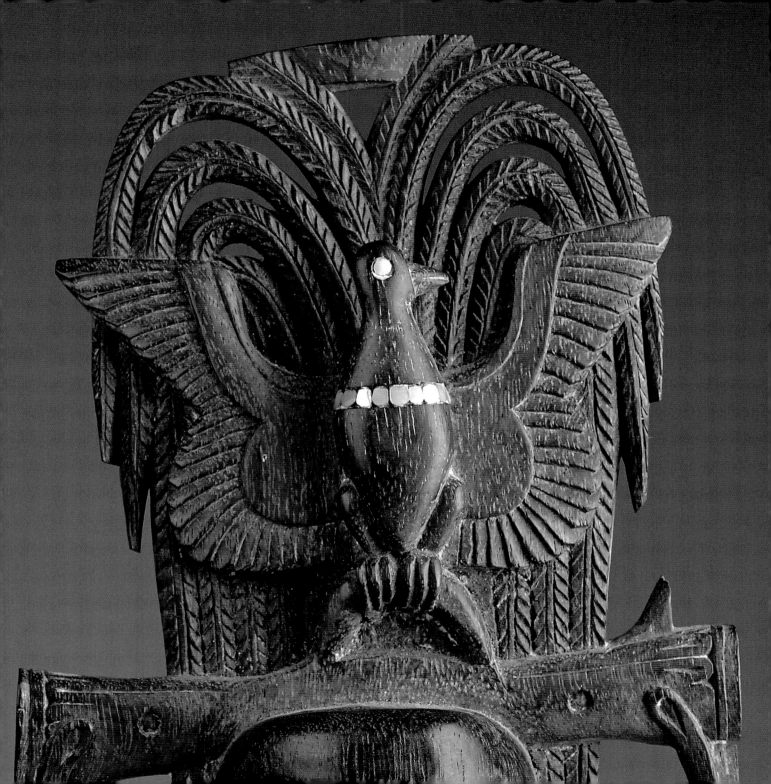

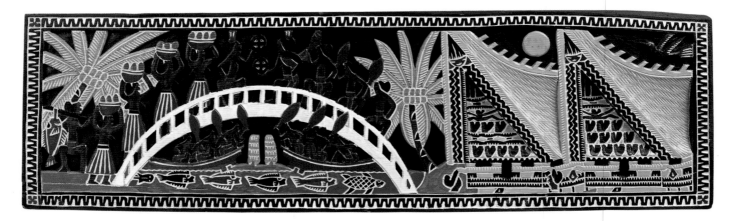

Ngiraibuuch Skedong, storyboard with *bai* and bridge.
Belau (Palau), 1987.
Wood, paint. L. 85.5 cm. H. 25.5 cm. D. 3 cm.

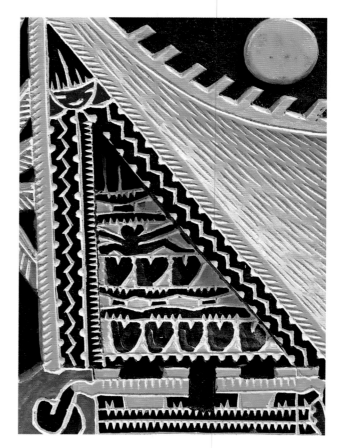

On the Micronesian island of Belau, artists relief-carve and paint boards with legends and other scenes of significance reflecting the island's rich storytelling traditions. The storyboards were first produced in the 1920s for the Japanese tourist market and were based on carvings which featured on the rafters of men's houses (*bai* – see glossary). The distinctive peaked roofs and painted facades of the Belauan *bai* can be seen on the right-hand side of this board. The *bai* remains a key symbol of Belauan identity and a place where traditional knowledge is handed down.

Ngiraibuuch Skedong has depicted a scene of early Belauan life, with women carrying taro towards the *bai*, being met by men carrying fish. These are the accepted roles: women traditionally provided staple plant foods and men provided fish and other meats. Below the bridge are canoes, fish and a turtle, and a low island or atoll with two trees in the distance. Recently, carvers have been creating unpainted storyboards of varnished wood. Tourists have assumed these are more 'authentic' and buy them in preference to the boards that follow the painted tradition. Painted boards are now hard to find.

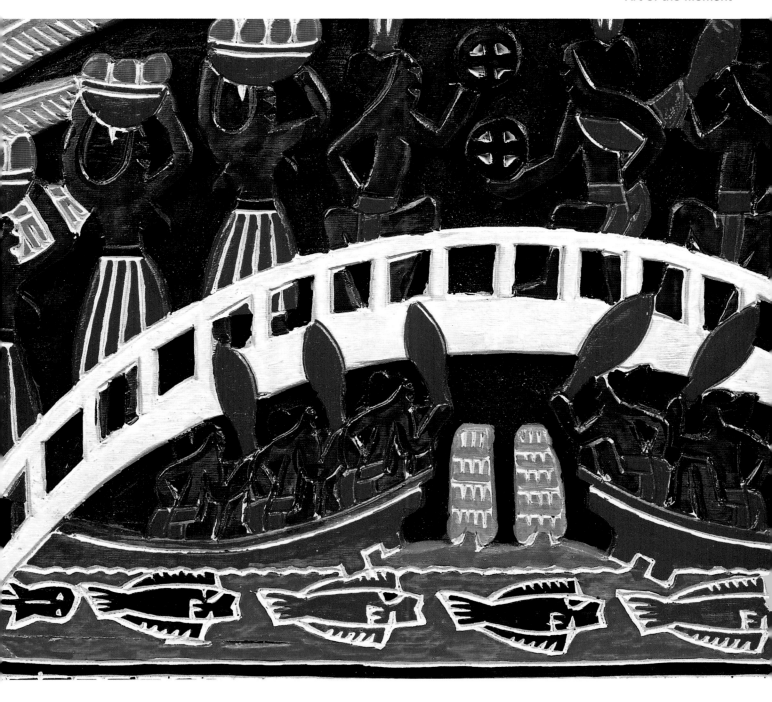

3

Sea of Islands

The history and identity of Pacific islanders are deeply connected to the sea. From the first intrepid explorations by canoe out from Southeast Asia into Pacific waters, most islanders have drawn physical and spiritual sustenance from the sea. Even though Pacific peoples live in an increasingly urban world, there are deep connections that remain in most communities to the bays, lagoons, reefs, seas and deep oceans surrounding them. Epeli Hau'ofa, one of the Pacific's most influential intellectuals, famously wrote of 'our sea of islands', calling on Pacific Islanders to see themselves as unified by the sea that connects them, rather than as cut off and weakened by isolation. This has been a powerful idea throughout the Pacific.

Underpinning the cosmology of many Pacific Island cultures are the legends of the founding gods pulling up their islands out of the sea. In many places, oral histories tell of ancestors arriving by canoe, recording the early voyages made on double-hulled sailing canoes across great expanses of ocean.

Sea routes of ancient Austronesian-speaking ancestors, the peoples who achieved the last of the great human migrations, can be traced in the archaeological and linguistic record, moving in gradual stages eastward from the western Pacific. From Southeast Asia and Melanesia, generations of people looking for new homelands sailed out of sight of land into unexplored waters – an extraordinary leap into the unknown. Carrying their distinctively decorated 'Lapita' pottery with them, these people made landfall on islands in the western Pacific, then in Fiji, Tonga and Samoa between 1100–900 BC. The long-distance voyages continued, reaching the Society Islands in the central Pacific in the early centuries AD. Settlers eventually reached the furthest eastern islands by AD 1000 and according to recent evidence, Aotearoa (New Zealand) by AD 1200–1300.

Many Pacific peoples live in inland regions particularly on the large islands of Papua New Guinea and Aotearoa – and many have lifestyles that are unconnected to the coast. But the sea remains a pervasive feature of life for many others.

In the Caroline Islands in the northwestern Pacific, the working and social lives of men are centred on a canoe house. It is where canoes are built and repaired, as well as the site for magic relating to safety at sea and successful fishing. As one commentator has said, 'To

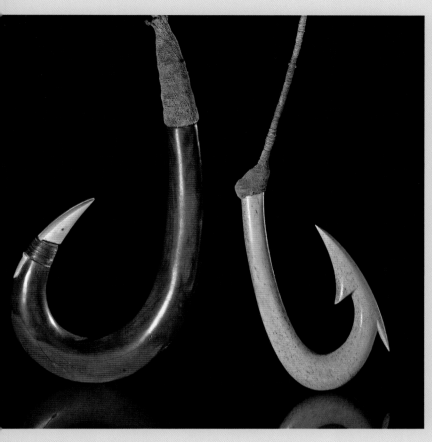

Chief's shark hooks.
Hawai'i, 1700s. Wood, bone, vegetable fibre.
L. 37 cm and 23 cm (without lines).
In Hawai'i, chiefs were called 'sharks that walk on land'. Both chiefs and sharks were powerful, ruthless beings, with close connections to the gods. Shark fishing, with hooks such as these or with slip nooses, was the elite preserve of chiefs. It is said that they would use human flesh to bait their hooks. The wooden hook (left), made from a branch that had been tied to grow into a curve, is pointed with human bone, for the *mana* it possesses. When Captain Cook and his crew (the first Europeans to land in Hawai'i) arrived in 1778, the Hawaiians traded eagerly for goods and gave high-class gifts. The bone hook (right) appears to have been one of them. It was brought back to London after Cook died in a skirmish on shore.

be a man is to be identified with a canoe as fisherman, sailor, navigator, and canoe builder.' (M. Montvel-Cohen, 1987).

Throughout the Pacific, canoe builders and navigators have based their skills on an intimate knowledge of their marine landscape passed down through generations. Historically, those young men who chose to become navigators learned over years to read the sea, pinpointing the rising and setting of stars on the horizon each night, the signs of intersecting currents and swells, the presence of specific birds, fish and seaweeds, cloud formations, and the particular reflections on the underside of clouds. Fishing, too was based on detailed knowledge of each type of marine creature, in each of its life phases. Fishing tools – including beautifully carved shark hooks, fishing kites, nets and spears were usually crafted to target specific species.

Of course, the rising sea level, pollution, coral bleaching and overconsumption are now challenging the ocean's capacity to support human life, but on smaller islands, people remain intimately entwined with the sea, relying on it to a greater or lesser degree for their food, resources and wealth from pearls, fishing and tourism. The ocean is a major part of what it means to be a Pacific Islander.

War canoe prow (*tauihu*).
Aotearoa (New Zealand), probably late 1800s.
Wood. L. 180 cm. H. 98 cm. D. 5 cm.

This dramatic war canoe prow was given to a visiting European in 1903 by Tawhiao, a chief from the Waikato region of Aotearoa (New Zealand). It would have been carved by specialists working for months in a state of *tapu* (spiritual restrictiveness), avoiding the touch of food or women, to create each of the powerful elements of a *waka taua* (war canoe). War canoes carrying up to eighty warriors, fronted by a dramatic prow such as this, would go to battle, calling on the power of the ancestral authority of Tūmatauenga, the divine ancestor of war. Figures of Tūmatauenga and Tangaroa, divine ancestor of oceans, are often featured in the carving of the tall stern and prow projections. The *takarangi* spirals (double-spiral whorls) typically represent the arrival of knowledge and light into the world.

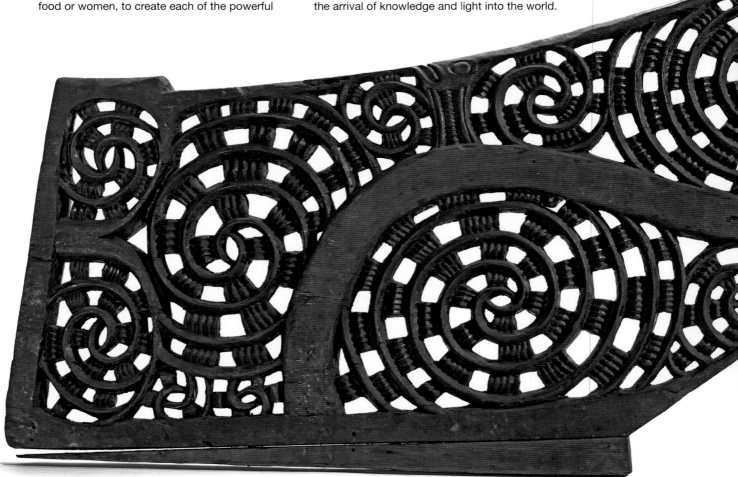

Waka (canoes) have had a central role in Māori communities. Not only necessary for battle, fishing and travel, *waka* were – and still are – integral to tribal identity. There are around forty great voyaging *waka* still remembered today on which the ancestors of the Māori voyaged to Aotearoa from their Pacific island homelands (in the vicinity of Ra'iatea, Society Islands), some twenty or more generations ago, up to AD 1400.

Robert Marsh Westmacott,
Bow of a War Canoe, New Zealand.
In his *Drawings of New Zealand*,
1840. Watercolour. H. 17.5 cm.
L. 26.4 cm. National Library of
Australia, Canberra (NLA.pic-
an3458375).
A canoe prow strikingly similar to the prow above, with feathered ornamentation (*ihiihi*).

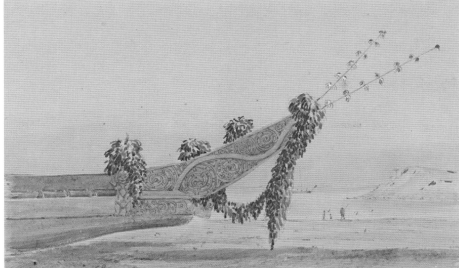

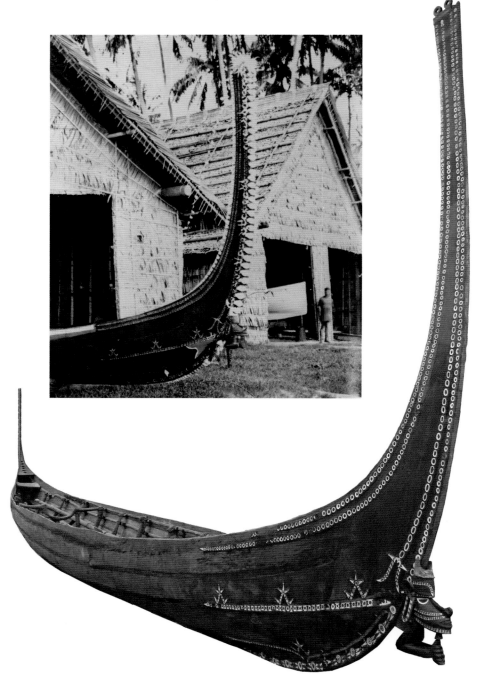

War canoe.
Vella Lavella, Solomon Islands, 1910.
Wood, pearl shell, vegetable putty.
L. 1153 cm. Stern: H. 340 cm.
Prow: H. 278 cm.
INSET: **Photograph of the canoe with shell valuables, in canoe house, Vella Lavella, c.1910. Silver gelatine print.**
H. 17.7 cm. W. 12.7 cm. Photo:
R. Broadhurst-Hill. British Museum Oc,B36.4

In about 1910, a man called Jiosi Angele of Vella Lavella, one of the Solomon Islands, built this elegant shell-inlaid vessel as one of a pair of headhunting canoes. Like other canoes from the region, the hull is plank-built. The figurehead is a guardian figure looking out for dangers at sea.

Prestigious canoes such as this were kept safely in canoe houses until needed for a raid. This one, however, was made after the British colonial government had banned headhunting. Angele suggested a canoe commission to a colonial officer, R.Brodhurst-Hill, to see if he could gain permission for a final expedition. Brodhurst-Hill funded the construction, but was obliged to 'let the whole side down' about the raid. He kept the canoe and it was later sold and shipped to the Lady Lever Museum in Port Sunlight, England, then donated to the British Museum in 1927. Photos of the canoe have been sent to the community in Vella Lavella. They identified the canoe and its name: *Lotu*, meaning the 'Christian Church', or 'prayer'.

Sea spirit figure.
Makira, Solomon Islands, pre-1890s.
Wood, feathers. H. 72 cm.

Sea spirits were once part of the array of dangers that fishermen in the Solomon Islands confronted. Travelling on rainbows and capable of 'shooting' fish at people like arrows, these spirits were wild – not bonded to people as ancestor spirits were. Fishermen would keep on the alert for rainbows in sun showers and waterspouts – both sure signs of the sea spirits' presence. In southeast Solomon Islands, wooden effigies of sea spirits, such as this lively figure, were attached to the apex of a chief's canoe house to guard against intruders. The figures were given offerings such as almonds, taro and flying-fox teeth to win favour and success in catching the much-prized bonito fish. Carved with a head incorporating a large fish, the figure also has hands and feet like garfish tails.

Captain E. H. M. Davis collected this figure during his punitive expeditions for the British colonial authorities in the early 1890s. He destroyed villages while dealing with the violence between islanders, Australian traders and labour recruiters. The Solomon Islands were taken over as a British Protectorate in 1893.

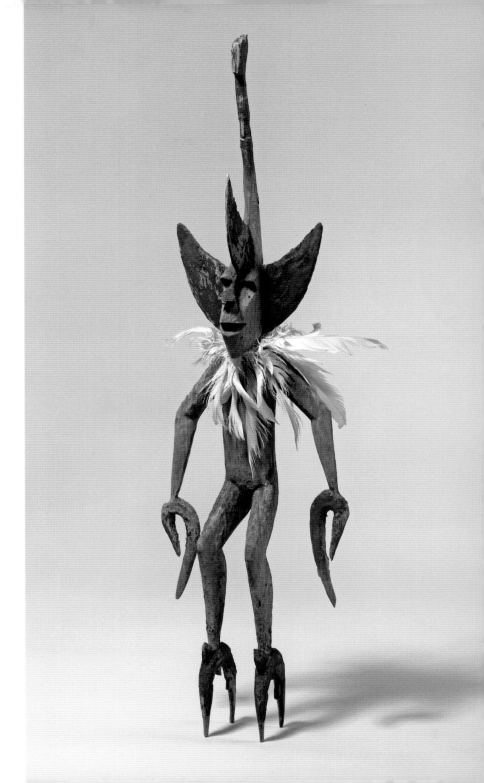

Ocean navigation chart (*rebbelib*).
Marshall Islands, before 1944.
Wood, fibre, shells. W. 72.5 cm. H. 26.3 cm.
Below is a navigator's map. With the swells, currents and islands translated into palm-leaf ribs and shells, charts such as this were made only in the Marshall Islands where they were mnemonic devices to teach and to refresh the memory before heading out onto the open sea. Micronesians, in the northwestern Pacific, are renowned for their refined navigational and sailing skills. Many of the island groups are made up of low-lying coral atolls, which means sailors are quickly out of sight of land. Young men training to be navigators would learn to read the ocean for signs of currents and the 'reflections' of islands, in the way intersecting swells rocked the canoe.

There were several types of navigational charts. Some were made to teach common wave patterns around generic islands; others recorded specific features in the archipelago, mapped as travelling out from a starting island. Each navigator designed his own chart. This one is unusual as most were basically rectangular or cross-shaped. Canoes and other types of boats retain their essential daily usefulness within Micronesia today.

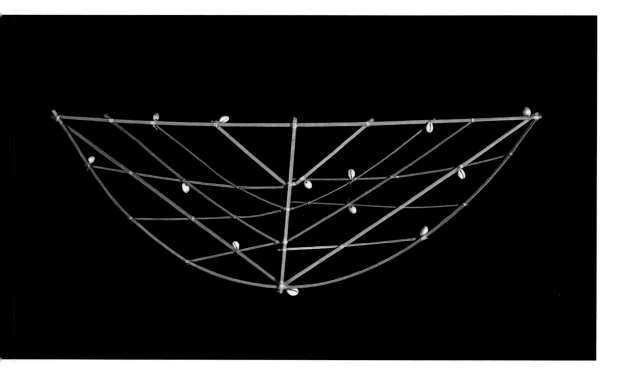

Canoe sail (right) and detail of the sail's top edge (left). Polynesia, pre-1800s.

Pandanus, hibiscus fibre? L. 515 cm. W. 366 cm.

BELOW: Researcher Tahiarii Yoram Pariente and conservator Monique Pullan examining the sail with a lens. British Museum, 2008.

This triangular canoe sail from the eastern Pacific is a rare survivor from the era of inter-island voyaging. Like most Pacific sails, it would have been plaited by women, using fine strips of pandanus leaf. There are rows of darker geometric patterning, possibly of hibiscus fibre. The sail was given strength and structure by being constructed of long, overlapping mats, each progressively shorter.

Lashed between two masts, the widest part of the triangle was placed at the top – an efficient form used in many parts of the world. Voyaging canoes for long-distance migration and trade would typically have double hulls, a platform and a hut to shelter the crew, livestock and supplies.

In Polynesia, production of sails had mostly ended by the mid-1800s. There are three early Polynesian sails at the British Museum; the only known examples in the world. Each informs the practice of Pacific Islanders and others working on reclaiming the skills of making and sailing voyaging canoes.

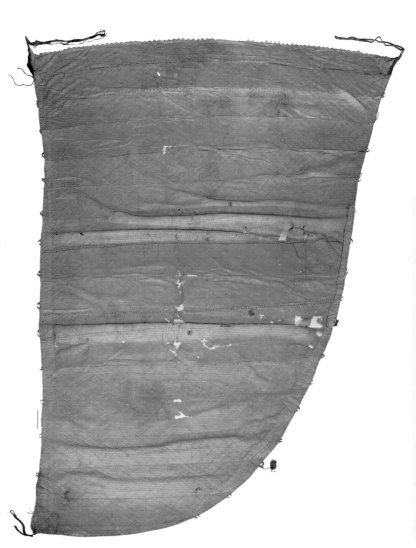

Ceremonial fish mask.
Attributed to Mabuiag Island, Torres Strait Islands
(Australia), 1800s.
Turtle shell, shell, cassowary feathers, seed pods,
red pigment, fibre. L. 142 cm. W. 41 cm. H. 71 cm.
In the Torres Strait Islands, between Papua New
Guinea and Australia, people live in close integration
with the sea. The striking masks and headdresses
of the region typically represent sea creatures (such
as this triggerfish or black kingfish), often combined
with human faces. On a panel between the pectoral
fins, curving behind the wearer's head, smiling human
figures, apparently dancing, have been incised and
rubbed with lime (see below). The mask was made of
plates of hawksbill turtle shell, heated and bent into
shape. Piercing the plates allowed them to be sewn
together, after which cassowary feathers and seed-pod
rattles were attached.

Men wore these masks, with skirts of rustling grass,
in a variety of ceremonies. Some were to encourage
crops to flourish, others to initiate boys, or to help
send the spirits of the recently deceased on their way.
Today artists make such masks of metal, wood and
plastic for cultural displays – vividly painted 'dance
machines' featuring articulated sharks, aircraft and
other significant features of life on the islands.

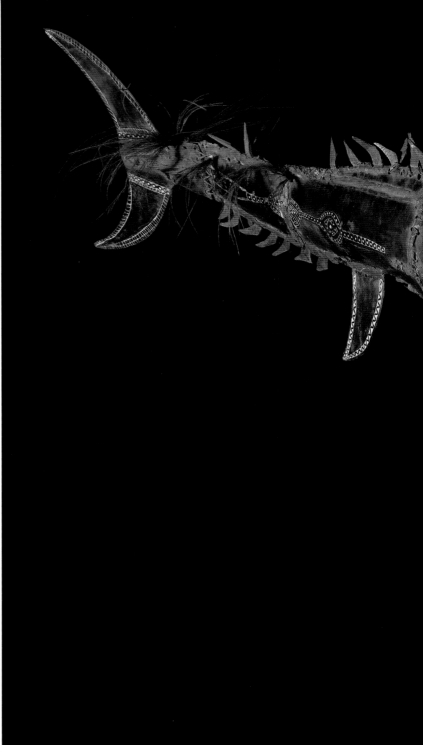

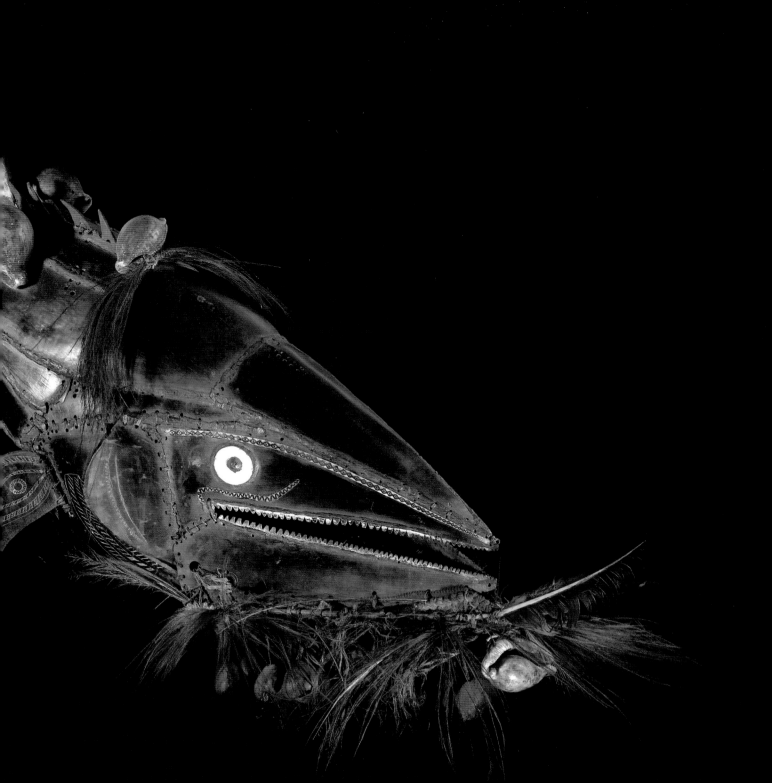

Canoe splashboard.
Trobriand Islands, early 1900s.
Wood. H. 45.5 cm. W. 47.3 cm.

Trobriand Island canoe prows and splashboards are well known for their elaborate, swirling carvings imbued with symbolism. This splashboard features a human figure and is full of the symbolism of totemic animals. The two lobes at the top of the board, for instance, mirror butterfly wings, referring to their easy flight and the easy travels the canoe will make.

For centuries, Trobriand Islander men have paddled their elaborately carved and decorated canoes in the cyclic *kula* trade route around the rim of Milne Bay. Highly complex in its layers of meaning and the management of status, the *kula* trade continues to occupy much of the energy of communities in the region. Shell arm rings are traded anticlockwise around the Kula Ring, while shell necklaces travel clockwise, creating bonds of obligation with other communities. The complexity of the canoe carvings is intended to intimidate and mesmerize potential trading partners.

'Once the canoe is shaped, you project your own *mwasila*, your radiance, onto the canoe and give it its own personality – life.'
(John Kasaipwalova, chief of Kwenama clan, Kiriwina Island, 1982)

The anthropologist Bronislaw Malinowski (1884–1942) acquired this board during his fieldwork between 1915 and 1918. Unfortunately, its colouring has worn off, so it lacks the enlivening power of the red, black and white hues of active *kula* carvings.

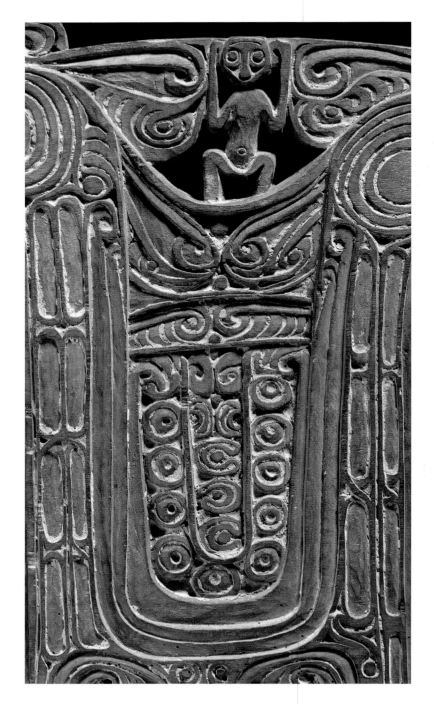

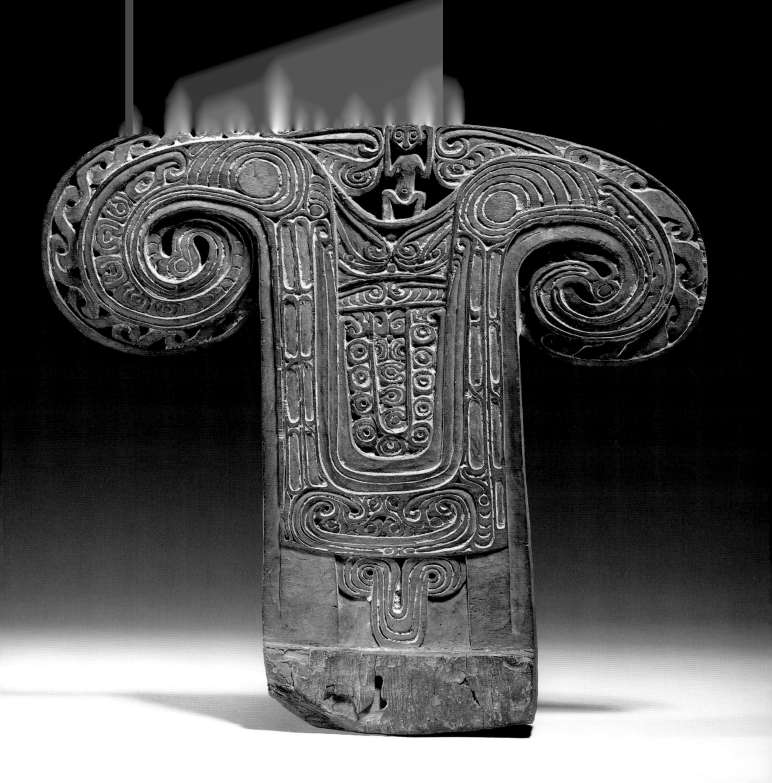

4

Gods and Spirits

Some of the most striking objects created in the Pacific were those designed to contain the essence and force of supernatural beings. From massive, grimacing figures to delicate birdman kites, the objects in this section were intended to make the supernatural tangible. They provided a way to communicate with and control the power of gods and spirits.

In Melanesia and Micronesia, communities tended to focus – and often still do – on communicating with the ghosts of dead community members. A range of gods is acknowledged in some areas. The other significant incorporeal beings are spirits of animals and birds, and spirits inhabiting the landscape. The Elema people of the Gulf of Papua, for instance, would stage festival-like ceremonies (see right) with large, often humorous masks and costumes to keep the spirits of the bush and sea happy. Across New Guinea, sorcery and magic were, and still are, a pervasive part of life, practised with the assistance of spirits.

Historically in Polynesia, priests managed the relationship between the world of the dead and the world of the living. They made sacrifices (sometimes human) to placate and

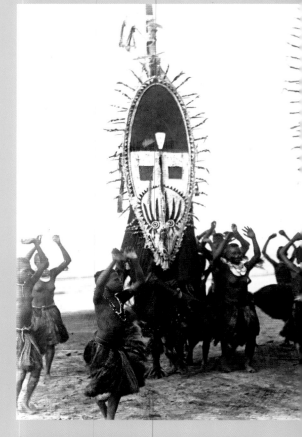

Ceremony with *hevehe* (totem) masks, Elema people, Purari Delta, Papua New Guinea, late 1800s. Glass plate negative. H. 10.4 cm. W. 8.2 cm. Photo: Rev H. M. Dauncey. C. G. Seligman Album, British Museum, Oc,G.N.2004.

gain the support of the gods. Polynesians interpreted signs from the world of the dead in the songs and actions of birds, sea creatures, weather and other phenomena in the local environment. Birds had a particularly important role in Polynesia as beings that

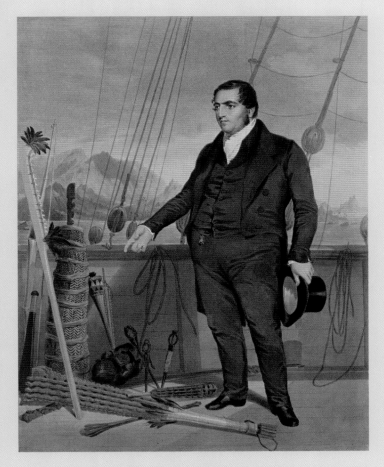

Henry Anelay, *John Williams, Missionary to the South Sea Islands.*
J. H. Lynch, Lithograph. London, *c.*1836–41. H. 40.7 cm. W. 31.9 cm.
National Library of New Zealand, Wellington. C-020-004.

or professional groups such as carvers would have their own sacred sites and objects for interacting with spirits specific to them. There was a tradition of changing allegiances to gods and spirits; if one proved ineffective, another could be tried.

Christian missionaries had a deep impact across the Pacific from the mid-1600s with the arrival of Spanish Catholics in Guam. In 1812, fifteen years after the London Missionary Society moved into Tahiti, an influential chief decided to convert. A number of his people travelled as missionary 'teachers' to other islands. They encouraged leaders to renounce their gods and destroy the sculpted deity images that provided the material link to these beings. By the mid-1800s Christianity was well entrenched in Polynesia and missionaries were increasing their efforts in Melanesia and Micronesia. It was a time of epidemics, political insecurity and economic changes following in the wake of engagement with the West. The old gods were losing power. The adoption of Christianity was accompanied by widespread suppression of cultural practices. Christianity is a fundamental part of Pacific life today, but as part of the cultural recovery that is underway, older spiritual connections are being revived.

could travel between the worlds of the living and the dead.

Across the Pacific, specially trained ritual specialists engaged with supernatural beings on sacred sites such as stone platforms or in carefully enclosed ceremonial houses. On a smaller scale, in some places, family groups

Ivory goddess figure.

Tonga, late 1700s to early 1800s.

Whale ivory. H. 12 cm. W. 5.4 cm. D. 3.9 cm.

A Tongan carver, a *tufunga fonolei* (jewellery-maker), created this lovely goddess figure out of sea-mammal ivory – probably a whale's tooth – more than 200 years ago. At the time of Captain James Cook's visits to the Tongan archipelago, the islanders paid reverence to a range of gods and goddesses through small figures such as this. This figure may represent Hikuleo, goddess of Pulotu, ancestral homeland and the world of the dead. After Christian missionaries eventually convinced Tongan chiefs to renounce their gods in the early 1800s, these figures were often destroyed or desecrated. In Tongatapu, the archipelago's main island, Christian denominations and new forms of worship developed, sometimes combining Christian practice with older Tongan practices.

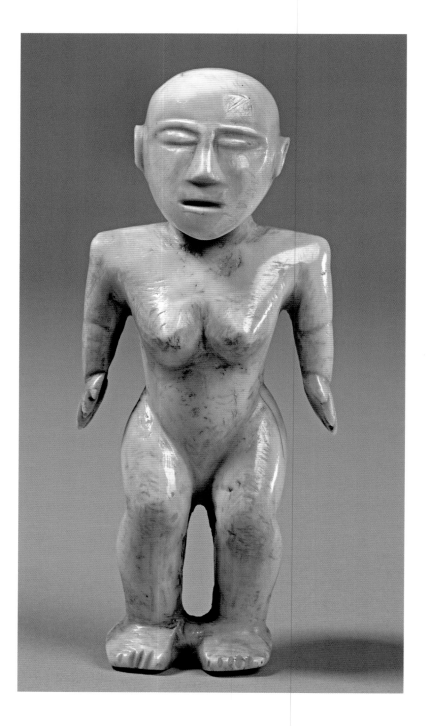

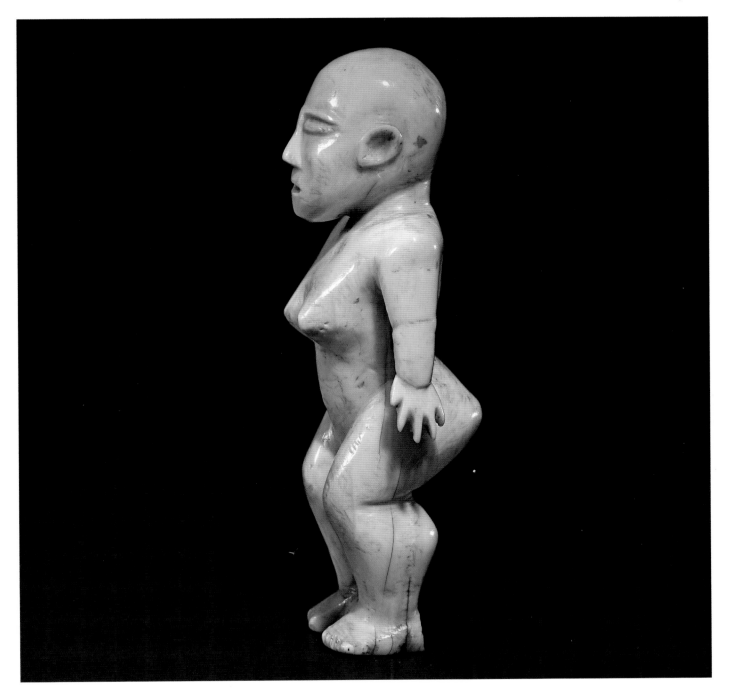

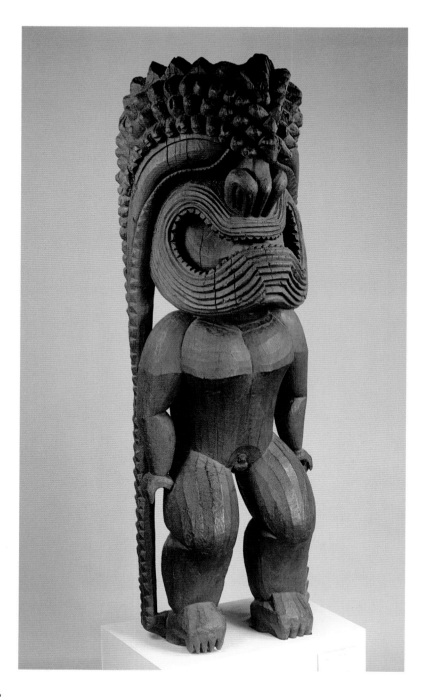

Kū image (*ki'i*).
Hawai'i, *c.*1790–1810.
Breadfruit tree wood. H. 267 cm; W. 69 cm.

This massive figure once guarded a Hawaiian temple ground (*heiau*). Donated to the British Museum by W. Howard in 1839, this powerful *ki'i* is one of the masterpieces of the Pacific collection. It had been commissioned by the great chief Kamehameha (*c.*1758–1819), who was the first to subjugate and unify the islands of the Hawaiian archipelago and become its first king. It represents the god he embraced: the war god Kū-Ka'ili-moku (Kū, the Island Snatcher). The figure's aggressive mouth demonstrated the god's power and his taut stance showed his strength and readiness for action. Priests called the war god into a *ki'i* during rituals on the *heiau*. This one was carved out of a single piece of breadfruit wood in the distinctive style of Hawai'i's Kona region. Kū's 'hair' is shown as four rows of animal heads, probably dogs, one of the body forms Kū could adopt. These huge temple figures hold deep significance for many Hawaiians today. In 2010 the Bishop Museum (Honolulu) brought together the three remaining large *ki'i*. The Bishop Museum's Kū image was joined by this one from the British Museum and another from the Peabody Museum of Natural History (Salem, Massachusetts), united in the islands for the first time in more than 170 years.

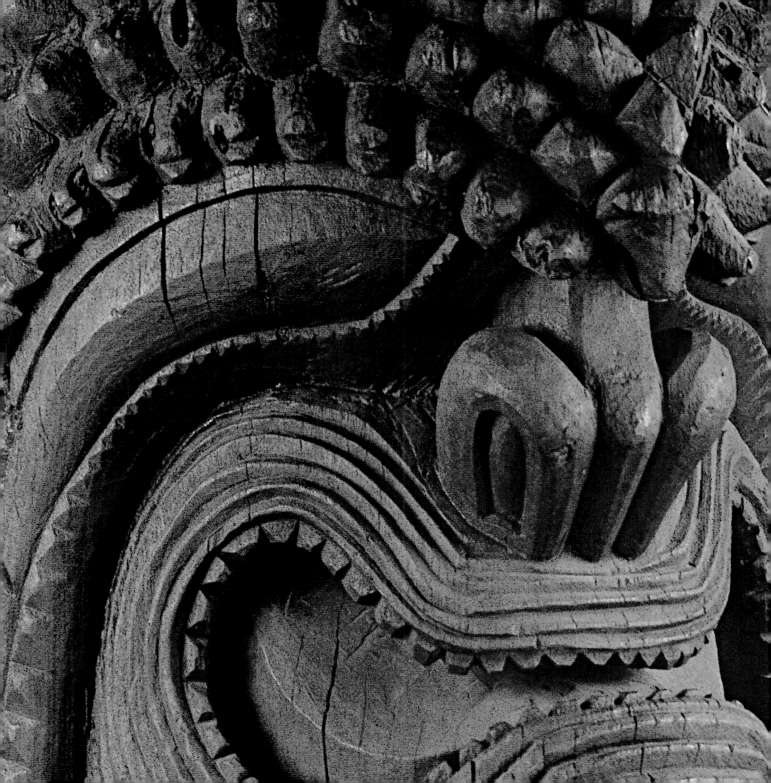

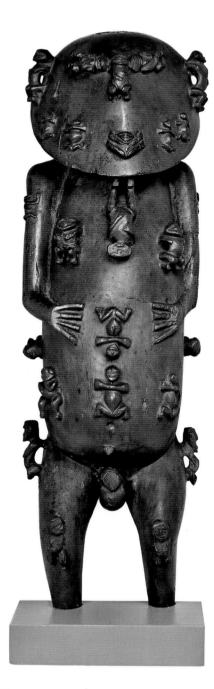

God figure.
Austral Islands, before 1821.
Wood. H. 116.8 cm. W. 31 cm.

One of the Pacific's most famous sculptures, this is a figure of a creator god, probably A'a, of the island of Rurutu in the Austral Islands. Its features are formed of thirty small human figures – appropriate for a god of creation. A'a was carved with a hollow head and torso covered by a panel at the back. The cavity may have been designed to hold the skull and bones of a deified ancestor. In 1821 a group of islanders from Ra'iatea (near Tahiti), recently converted to Christianity, sailed to Rurutu. They returned to the London Missionary Society station in Ra'iatea with surrendered Rurutu 'gods', including A'a. At that time the cavity contained twenty-four 'small gods'. The missionaries shipped A'a to London for triumphant display in the Missionary Museum. In 1911 A'a was sold to the British Museum. Since then this powerful figure has been the focus of scholarship, exhibitions, poetry and prayers.

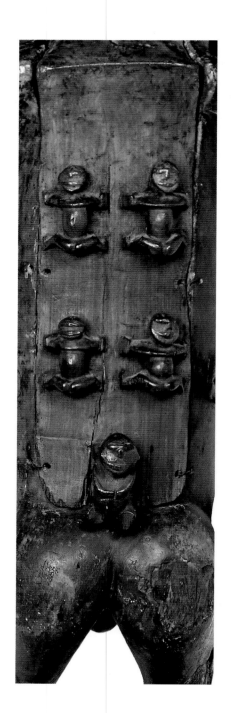

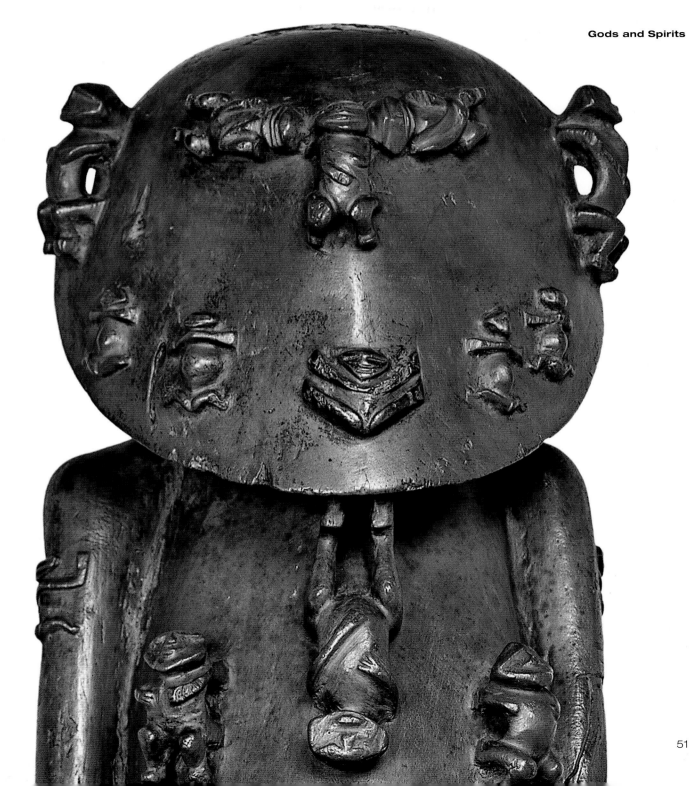

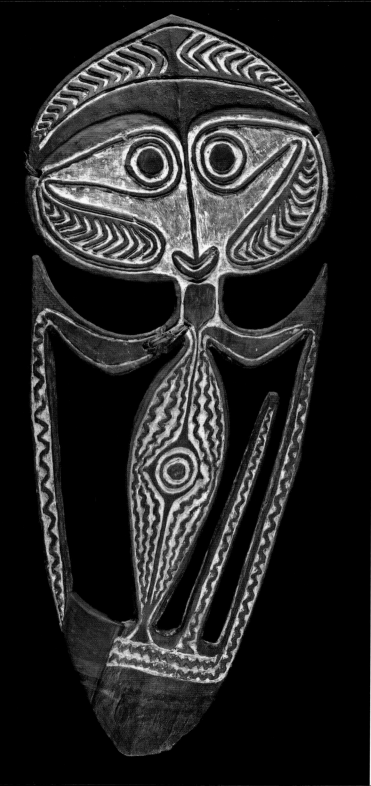

Skull rack (*agibe*).
Gulf Province, Papua New Guinea, before 1904.
Wood, rattan, vegetable fibre. H. 117 cm. W. 49.5 cm.
INSET: Agiba Shrine from a Duba Daima, at Dopima,
Goaribari Island. From A. C. Haddon paper, Dec 1918.

This jaunty spirit figure is a skull rack. People of the Aird River delta, in the Gulf in New Guinea, would tie skulls with loops of cane to the two upright prongs (one of them had broken off this *agibe* before reaching the British Museum; conservators consolidated the gap). This rack was collected on the Cooke Daniels Ethnological Expedition to British New Guinea in 1903–04. The Kerewa (or Kerebo) people were, until the early 1900s, headhunters. They understood the spirit of a person as living within the skull. Keeping skulls of both enemies and ancestors within a men's house was seen to keep their useful, protective power within the community.

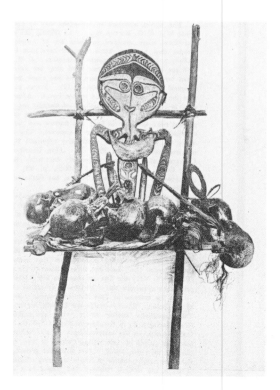

Magical charm (*marupai*).

Gulf of Papua, late 1800s. Coconut, vegetable fibre. L. 11.2 cm. W. 5 cm.

This is a *marupai*, a magical object of the Elema people. It contained the owner's spirit familiar, most likely a creature of the forest. *Marupai* were worn around the neck in small baskets. To make a *marupai* such as this, a carver would soften a dwarf coconut in water and enlarge the holes at the point, to create a nose and mouth resembling a pig (some would say a crocodile). Geometric clan designs and a double set of faces were carved and rubbed with white lime. The animal can be seen in profile. When the *marupai* is held vertically, the animal's eyes become the eyes of a human face.

Marupai were primarily made for initiated men; however, some women (notably midwives) could be granted permission to own one. Magical substances – aromatic bark, a seed or a sorcerer's bone – were put in the charm's open mouth. With spells cast, the *marupai* were seen to be able to fly and 'defy every law of nature and probability' (F. E. Williams, 1940). The spirit within could assist in a hunt, protect against illness or, when used by a sorcerer, kill enemies.

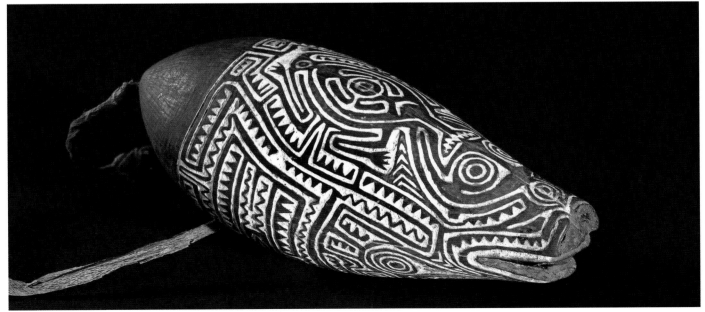

Priest's *yaqona* dish (*daveniyaqona*).
Fiji, before 1840.
Wood. L. 26.7 cm. W. 14 cm.

This elegant dish was highly sacred. With the dish laid on the floor of a spirit house and filled with a peppery narcotic drink, a priest would sip from it while possessed by his ancestor spirit. The *yaqona* drink (called *kava* in other parts of the Pacific) was sipped through a straw, as priests were *tapu* (taboo) during the rituals and needed to avoid touching food or drink which was destined for the spirit that possessed them.

Dishes for these *būrau* rites were mostly carved of sacred *vesi* (*Intsia bijuga*) wood and were more usually circular or bird-form dishes on elegant pedestals – the form of a man is rare. A British sea captain noted in 1849, on seeing a man-form dish, that the locals looked at it 'with evident respect as very sacred and uncommon'. He stated it was carved in a period 'long before the introduction of iron'. The dish you see here was collected in 1840 during HMS *Sulphur*'s visit to the islands. Fijians stopped the *būrau* rites after adopting Christianity. *Yaqona* is now served at ceremonial and social events out of a deep circular, multi-legged bowl, a public style of drinking that spread to Fiji from Tonga in the late 1800s.

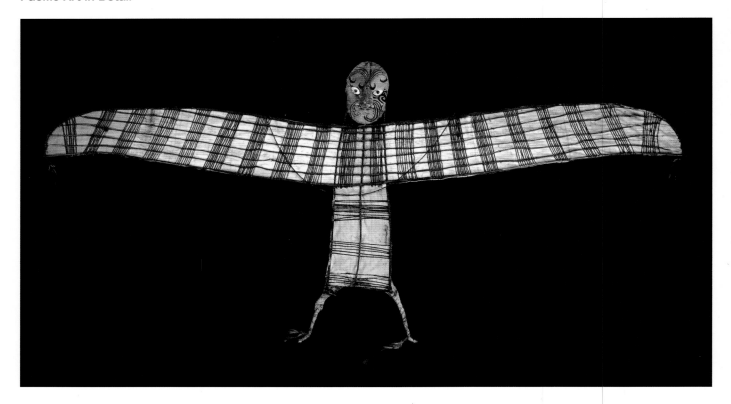

Birdman kite (*manu aute*).
Aotearoa (New Zealand), early 1800s.
Manuka wood, cotton, Kahu feathers
(New Zealand harrier hawk), fibre, pearl shell.
W. 207.5 cm. H. 145 cm.
This Māori 'birdman' kite (*manu aute or manu tukutuku*) is one of only two to have survived from the 1800s. The other is at the Auckland Museum. Made in the Bay of Plenty on the North Island of Aotearoa, this kite was made within the tradition of kite flying for spiritual purposes. In pre-contact times these kites were covered with *aute* (beaten barkcloth), but this is an object of its times, using imported cotton. Its face is a moulded mask with an inked facial tattoo.

There are rock engravings of birdmen in Aotearoa dating from about 1400. Birds have long been seen in the Pacific to be creatures providing a conduit between the tangible world of the living and the intangible realm of the spirit. Māori ritual specialists often flew *manu aute* to discern, in the pattern of swooping and stillness, the course of a proposed battle. If the long tail of a *manu aute* touched the dwellings of an enemy's *pā* (fortified settlement) during a battle, it sent down a bolt of destructive spiritual energy.

This particular kite was sold to a visiting British ship's captain, perhaps made on commission rather than for intended use in spiritual connections.

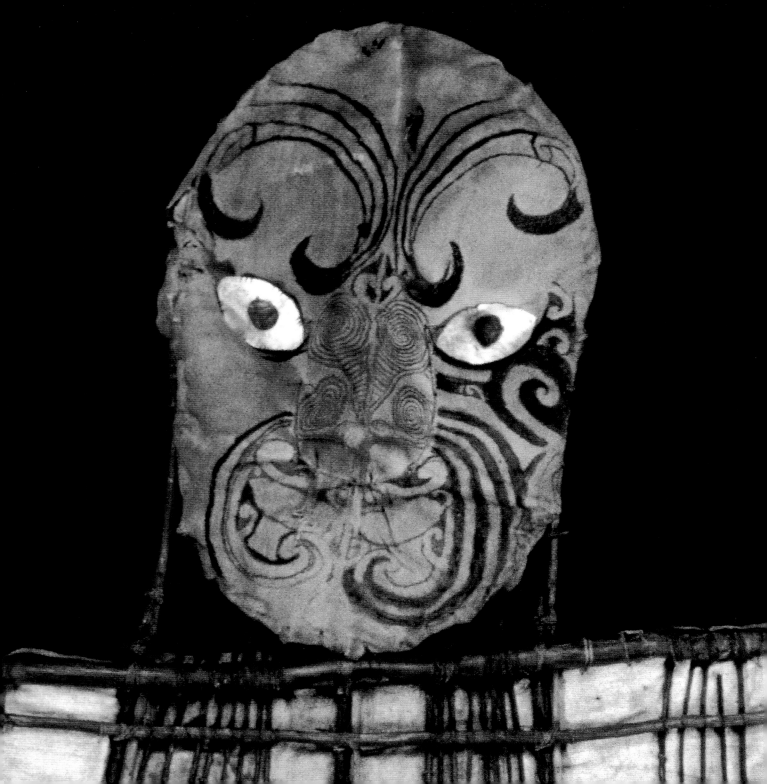

Wrapped staff god.
Rarotonga, Cook Islands,
1700s to early 1800s.
Wood, barkcloth, feathers. L. 396 cm.

In May 1827, on the island of Rarotonga, islanders brought this god figure and thirteen others in procession to the missionaries John Williams and Charles Pitman and their wives. This, the largest, Williams shipped to the Missionary Museum in London. The others were 'torn to pieces before our eyes', as Williams reported, or kept to decorate the rafters of their forthcoming chapel.

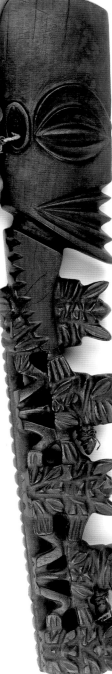

The staff god is a potent combination of male and female elements. The wooden core, made by male carvers, has a large head at one end and originally terminated in a phallus. Smaller figures in profile appear to be prominently male. Jean Tekura Mason, curator of the Cook Islands Library and Museum Society, suggests that other figures facing outwards could depict women in childbirth. The barkcloth wrapping, made by women, not only protects the ancestral power (*mana*) of the deity, but contains it, 'trapping' it within the layers. There are no other surviving large staff gods from the Cook Islands that retain their barkcloth wrapping as this one does. This was probably one of the most sacred of Rarotonga's ritual objects.

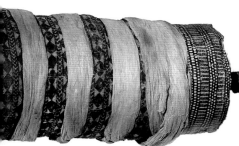

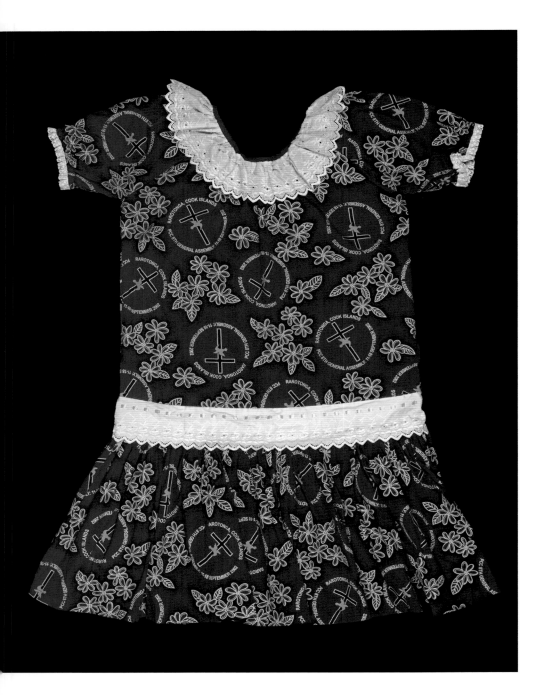

Island dress *(Mu'umu'u).*
Cook Islands, 2002.
Cotton. L. 131 cm. W. 99 cm.

One of the distinctive features of life in the Cook Islands is the central role of the Cook Islands Christian Church (CICC). The fabric of this dress was printed to mark the occasion of the Pacific Conference of Churches, which met in Rarotonga in September 2002. This group is an ecumenical fellowship of Churches from seventeen Pacific Island nations.

Christianity first reached the Cook Islands in 1821, with the arrival of missionaries from London and Tahiti. Church leaders worked to replace traditional activities and clothing with more modest, British versions.

Today, in many places in the Pacific, women often wear 'island dresses', based on those introduced by missionaries in the 1800s. These dresses, known by a variety of local names, have been embellished over time and according to local preferences. They are usually made of brightly patterned fabric, and adorned with lace, ribbons and decorative panels. In some islands, such as Vanuatu, women have used these dresses as a declaration of regional identity.

Living with Ancestors

Ancestors have a substantial presence in many Pacific societies. They are honoured, consulted for advice, included in ceremonies, and in day to day activities. The importance of ancestors is one of the unifying principles found from the far western Pacific to the far east, across a myriad of otherwise divergent cultures. This chapter presents some of the representations and vessels created to enable ancestors a tangible presence in a community.

In some Pacific cultures ancestors are traced back through generations to the original gods of creation. In most, particular culture heroes of early generations are identified, their stories told and retold. There is usually an active role for the more recent, known and named ancestors. Living descendants remember them, call on them for help and pay their respects, often as a part of everyday life.

Bird pestle.
Papua New Guinea, 9000–3000 BC
Stone. H. 36.2 cm. W. 7.3 cm. D. 9 cm.
The earliest ancestors traceable through archaeology, rather than oral history, are the agricultural people of New Guinea. Settlement has been dated to at least 50,000 BP (before the present), perhaps earlier. This stone pestle in the form of a bird has a very delicate neck so it was probably only used on ritual occasions, suggesting that it was made within a complex society with ceremonial systems in place. It also indicates the persistence of the cultural importance of birds, which were to become pervasive in Pacific myth and cosmology.

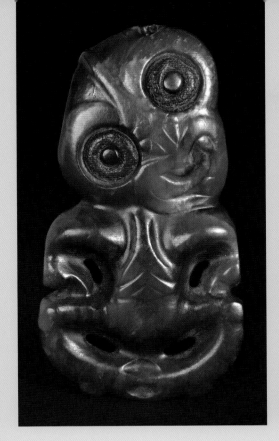

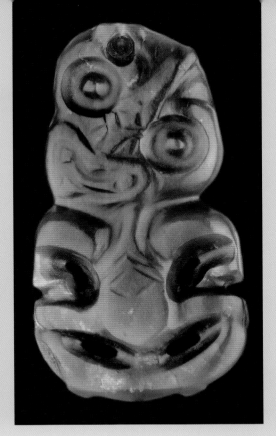

Hei-tiki.

Rotorua, Aotearoa (New Zealand), before 1906. Nephrite (*pounamu*), sealing wax. H. 11 cm. W. 5.5 cm. D. 1.2 cm.

This *hei-tiki* neck pendant is named in early museum records as 'Kaupwina' ('two stomachs'). It is highly unusual because it is double-sided. Like other *hei-tiki (hei* means 'suspended from the neck', *tiki* means 'human figure') this is a *taonga*: an ancestral treasure passed down the generations. It absorbs ancestral power as it is worn. When *hei-tiki* are given as gifts, they carry heavy obligations of reciprocity. Most are made in the north of Aotearoa of polished *pounamu*, a form of nephrite jade quarried in Aotearoa's South Island. *Tiki* eyes are usually filled with paua shell, but Kaupwina has eyes made powerfully red with European sealing wax, representing the divine power of great ancestors. There is a hole at the top for a suspension cord.

The *hei-tiki* is an ancient form that appears to pre-date Māori arrival in Aotearoa. It represents perhaps a woman in childbirth, a foetus or a spirit figure. During a *tangihanga* (death ritual), elders may place *hei-tiki* on or near the deceased, acting as a portal between the living, newly dead and the ancestors who previously wore it.

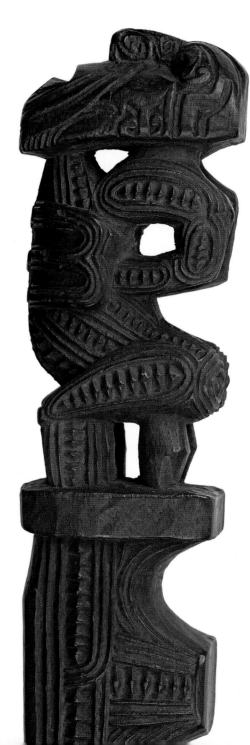

Genealogy staff (*rakau whakapapa*)
Aotearoa (New Zealand), 1800s.
Wood, nephrite (*pounamu*).
L. 103.5 cm. W. 5.3 cm.

In Māori society, *mana* (ancestral power) is a
prerequisite of effective tribal leadership. This *staff*
represents the flow of *mana* along a particular line
of descent from the *atua* (divine ancestors) down to
the living holder. Orators ritually recount *whakapapa*,
or genealogy. Before Te Korokai (a chief of Ngati
Whakaue) gave this *rakau whakapapa* to the Governor
George Grey, he used it as a memory aid to account
for eighteen illustrious generations before him,
establishing his hereditary right to leadership.

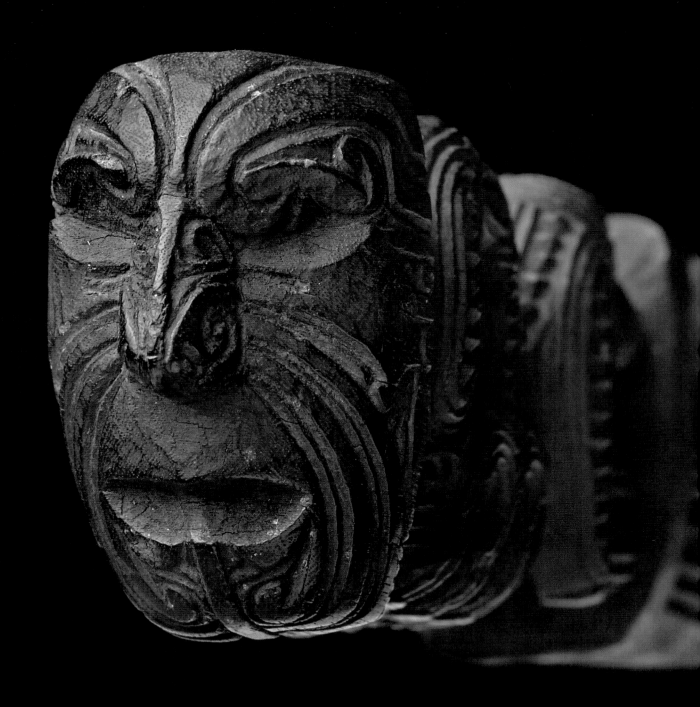

Ancestor figure (*moai*), Hoa Hakananai'a.
Rapa Nui (Easter Island), *after c.1100*.
Basalt. H. 242 cm. W. 96 cm. D. 47 cm.

This monumental ancestor figure is one of the most well-known objects at the British Museum. It has an extraordinary history. Originally carved out of basalt in Rapa Nui (Easter Island), at some point after AD 1100, it was probably moved, like other *moai*, on a 'log ladder', pulled by ropes. It would have been erected on a stone platform, possibly at the sacred site of Orongo, looking inland. Its eye sockets were inset with eyes made of red stone and coral.

From about 1400, deforestation and ecological collapse led to famine and conflict. Many islanders lost confidence in the efficacy of the ancestors. The *tangata manu* (birdman)

religion developed and focused on migratory terns and cycles of renewal. The Rapanui toppled many of the old *moai*. This one, named Hoa Hakananai'a, was the last to be the focus of ritual. While at Orongo, its back – previously carved with a ring and girdle design – was carved with new symbols of significance to the new religion: birds, dance paddles in the form of stylized human figures, and vulvas.

After Europeans arrived from 1722, diseases and raids by slave ships decimated the population. Few people were left by 1868 when a British expedition on the HMS *Topaze* arrived. A local warlord and a missionary led the expedition to Hoa Hakananai'a and assisted with its removal. Its red and white painted designs washed off when it was rafted to the ship. The name Hoa Hakananai'a is thought to mean 'lost or stolen friend'.

On reaching England, Hoa Hakananai'a was given to Queen Victoria, who presented it to the British Museum. Long displayed outside on the Museum's portico, it now forms part of an exhibition looking onto the Great Court. Hoa Hakananai'a remains a figure of great significance for the people of Rapa Nui.

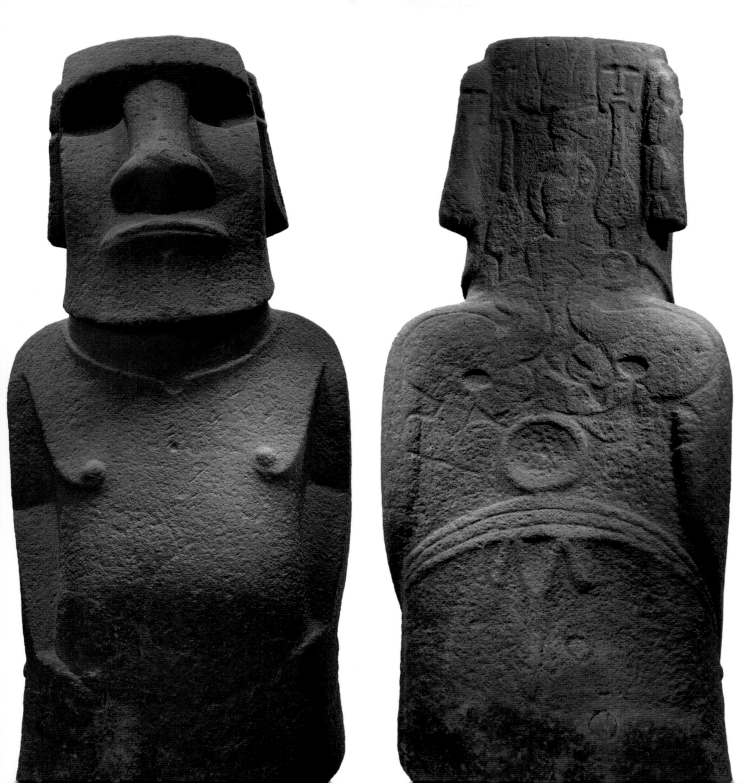

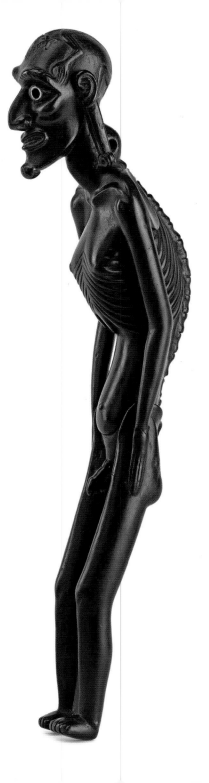

Male figure (moai kavakava).
Rapa Nui (Easter Island).
Wood, bone. H. 43 cm. W. 8.2 cm. D. 7 cm.

Like the great stone *moai* on the preceding page, *moai kavakava* such as this are thought to have been carved to honour ancestors. Symbols that probably relate to the birdman religion are relief carved on the head. They are part man, part reptile; in a range of other examples the figures are part bird. In Rapa Nui, knowledge of the reason for the *moai kavakava*'s bodily form has been lost. Some scholars argue that they represent the emaciation characteristic of the era of famines and diseases, when the birdman religion developed. Others feel that the prominent spine and obvious genitals are common in the Polynesia-wide imagery of genealogy, and relate to Rapanui concern with fertility, ancestral continuity, and transformation. What is likely is that priests or chiefs would wear a *moai kavakava* as a pendant, with string threaded through a lug on the back of the neck, during feasts and other gatherings of descent groups.

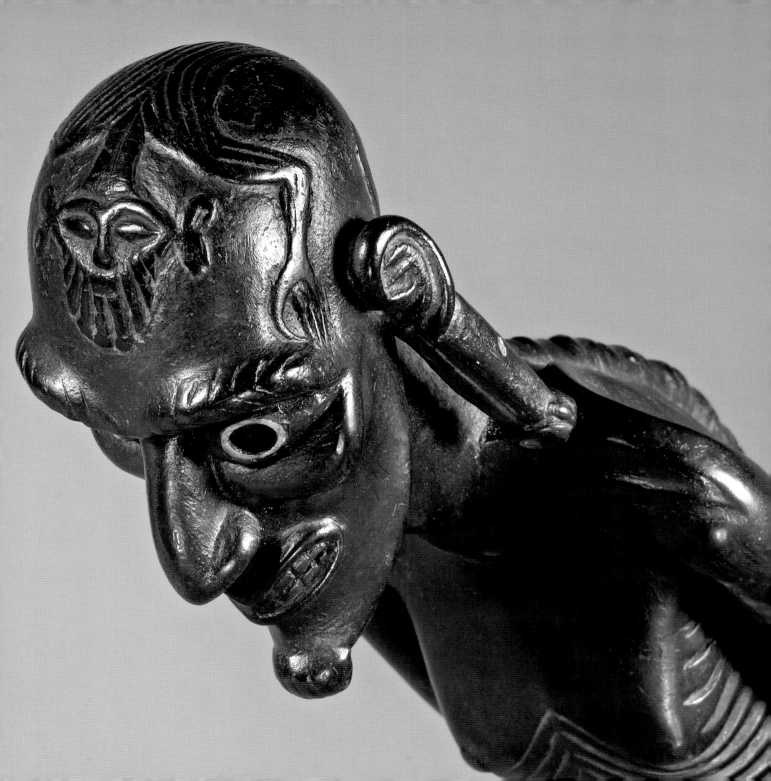

Mourner's costume (pārae).
Tahiti, before 1774.
Barkcloth, feathers, pearl shell, wood,
coconut shell. H. 214 cm. W. 93 cm.

This dramatic costume was worn during a violent expression of grief when a Tahitian chief died. The chief's family would enlist a group of mourners, and the leader wore a costume such as this. Rampaging through the district, where the deceased had held authority, sounding pearl-shell clappers in warning, the chief mourner wielded a long-handled weapon set with sharks' teeth. He and his soot-blackened attendants would attack anyone who got in their way.

When Captain James Cook's ship anchored at Tahiti for the first time in 1769, Joseph Banks took part in one of these *heva tūpāpa'u* ceremonies as an attendant. However, attempts to collect a costume failed. It was not until Cook's second voyage that chiefs agreed to part with them when the voyagers were able to offer sacred red feathers from Tonga in exchange. This is probably the costume a chiefly family gave to Cook in 1774. These costumes were expensive to make. Each pearl shell could cost as much as a pig. The shimmering chest 'apron' (*'ahu pārau*) was made of tiny drilled rectangles of pearl shell. A small hole in one of the shells of the face mask allowed the wearer to see. Some of the coconut-shell pendants attached to the barkcloth apron have notched motifs, a design that refers to ancestral genealogies.

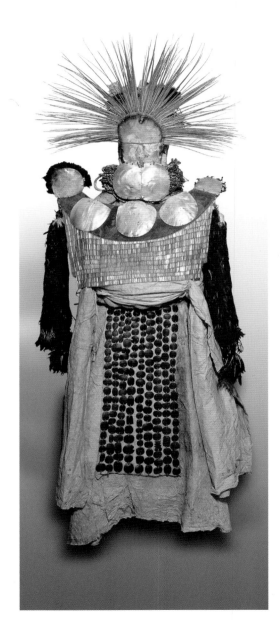

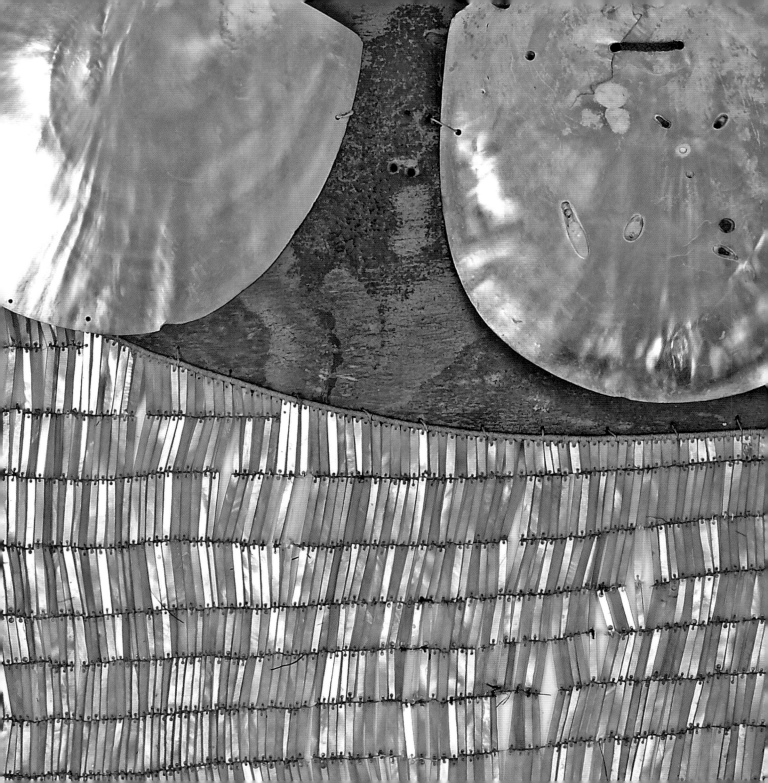

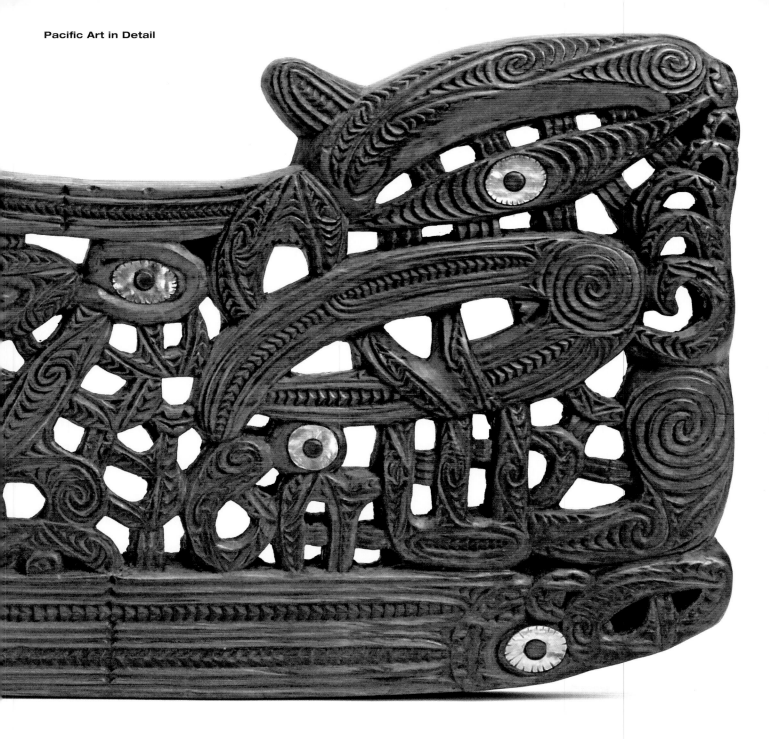

Meeting-house lintel (*pare*).
Aotearoa (New Zealand), before mid-1800s.
Wood, *Haliotis* (paua) shell.
W. 94.4 cm. H. 30 cm. D. 3.7 cm.

The flow of sacred ancestral power was and still is a fundamental force within Māori communities. This flow has been made tangible in carvings, particularly in the carving of meeting houses. A meeting house (*wharenui*) is the site of key events in the social and spiritual life of the community; it is also the embodiment of an ancestor. The ridge pole is the ancestor's spine, the rafters the ribs, and so on. Entering a meeting house, individuals pass under a carved lintel (*pare*). As they do so, they pass from the world outside, a place of everyday activities and conflicts, into a sacred space, a domain of peace and conflict resolution. At the threshold between these two realms they pass under a god.

The central god or founding ancestor figure on this lintel is flanked by several *manaia* figures, usually thought of as guardian figures, with stylized human, bird or reptilian features. These figures are always shown in profile. Glittering shell inlay on the eyes adds to the sense of life and movement in this important marker of the transition between realms.

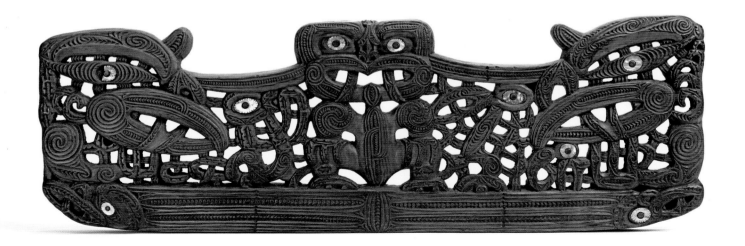

***Jipae* body mask.**

West Papua, Indonesia, *c.*1960.

Wood, seed, sago palm fibre, fibre, feather, cane. H. 188 cm. W. 76 cm.

This body mask was made in the secrecy of a men's house in Momogo village in the swampy Asmat region of West Papua. It was for a *jipae* ceremony, which urged the spirits of recently deceased people to leave the community and travel to *safan*, the world of the ancestors. Every few years villagers would prepare full-body masks such as this made from painted fibre rope with sago palm fibre fringing. Each mask represented the spirit of someone who had died since the last ceremony. The masks emphasized the otherworldliness of the spirits through abstract facial features and the wearer's non-human, often bird-like flapping movements. Although the identity of the wearer was hidden, it was of central importance: this was the person who had agreed to take on the deceased's responsibilities, particularly caring for children left behind.

The accompanying feasting and all-night dancing were designed to demonstrate to the deceased that their families were coping well, their children were well cared for and they could depart for *safan* with assurance that all was well. This mask was collected in 1961 by a field collector for Amsterdam's Tropenmuseum, before the Dutch relinquished rule of West Papua to Indonesia in 1962–63.

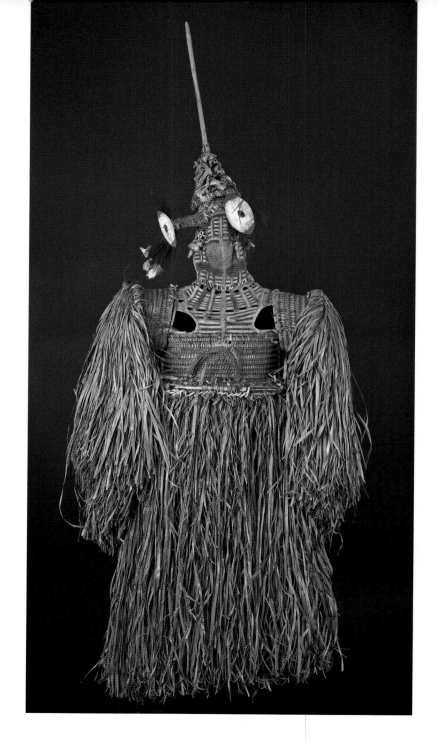

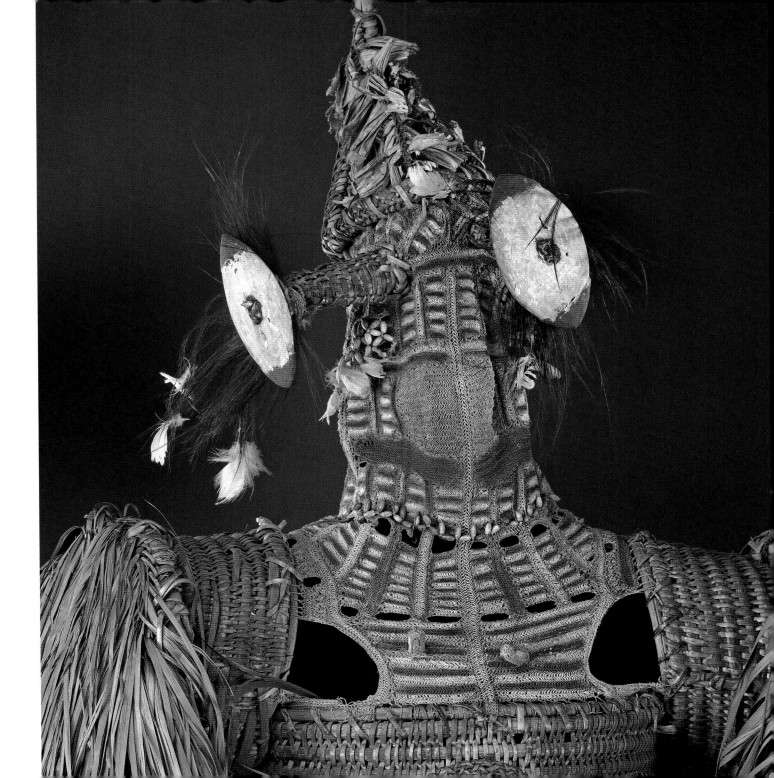

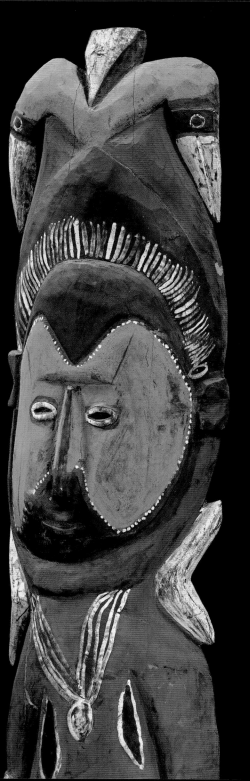

Female figure.

Abelam (Wosera) people, East Sepik Province, Papua New Guinea, 1974–75. Wood, shell, pigments. H. 180.5. W. 23 cm. D. 11 cm.

This life-size female figure was part of a crowd of similar, mostly male figures in the men's house of Sarikim village, in the East Sepik province of Papua New Guinea. A British Museum curator purchased the group of figures from the carvers in 1980. The figures had been carved to give physical presence to powerful clan spirits, *nggwalndu*, through a spectacularly long series of initiations. All of the figures feature a peaked headdress, painted face and body decorations. This woman is topped with a pair of hornbill birds – the hornbill is one of the most important totems of the Abelam. The pigments covering the figures are considered magical, giving the figures their beauty and power.

It takes an Abelam man twenty to thirty years to complete the full sequence of eight ceremonies required for him to become fully initiated. The rituals occur in the men's house (*korombo*), surrounded by a dazzling array of painted boards and adorned figures. As the men reach each new stage they are shown new objects. At the final stage, two large *nggwalndu* figures are revealed: the actual sacred objects that only the initiated may see.

Korwar **figure.**

Doré Bay, West Papua, before 1865.

Wood, glass. H. 28.4 cm. W. 12 cm. D. 11.5 cm.

The people of North-West Papua (now part of Indonesia) used to consult their recently deceased ancestors through *korwar* figures. A religious specialist (*mon*) made the figures for each relative on their death. The piercing eyes of this *korwar*, as in many others, are made from blue glass beads acquired in trade with Europeans. The *korwar* were kept in the home, treated with reverence and given offerings of tobacco and other desirable items. During an illness or before any serious undertaking, such as a journey or a major fishing expedition, a *mon* was called. He would address the *korwar*, bowing down in front of the figure with his arms outstretched. A Dutch missionary wrote in 1876: 'If nothing particular happens at such a consultation, it is a sign of the *korwar*'s approval: should the consultant begin to tremble, however, then that is a sign of the contrary, and he goes forth unsatisfied.' The advent of Christianity meant that by the end of the 1920s the making of *korwar* and its associated practices were abandoned.

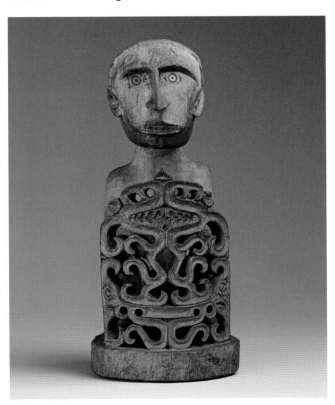

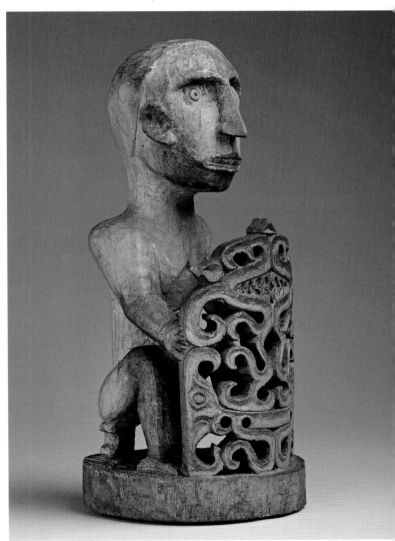

Malagan funerary carving.
New Ireland, *c*.1883.
Wood, paint, shell operculum.
L. 102 cm. W. 37 cm.

This mask was made for a ceremony to commemorate a deceased relative and to transfer land use rights from the deceased to the living. The family owned or purchased the right to use these particular designs of exuberantly intertwining birds, snakes and other beings, all biting or gripping onto each other, conjuring up the tangled forces of life and death. The *malagan* ceremonial system was – and still is – practised in northern New Ireland, an island off the coast of Papua New Guinea. When a family decides it is time to begin the series of ceremonies to honour their dead relative, they commission an artist. The artist carves the forms and may use an ember inserted into cavities to burn away wood – artists now also use power tools. During the ceremony, the carvings are painted then displayed on the front of the ceremonial house. Some are masks and are used when lifting certain taboos, as this one appears to have been. When the ceremony concludes, the carvings are disposed of: broken up, burnt, discarded in the forest or sold to outsiders. Nanati, a young chief of Kapsu village, sold this mask and other *malagan* carvings in 1883, to Hugh Romilly, a visiting British colonial officer, for a massive, status-laden pig.

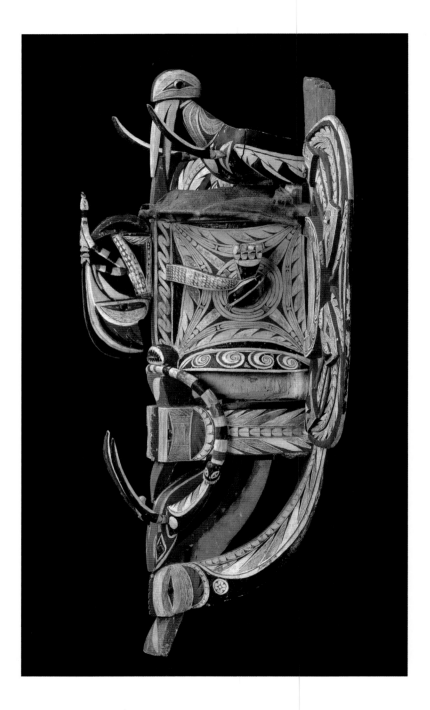

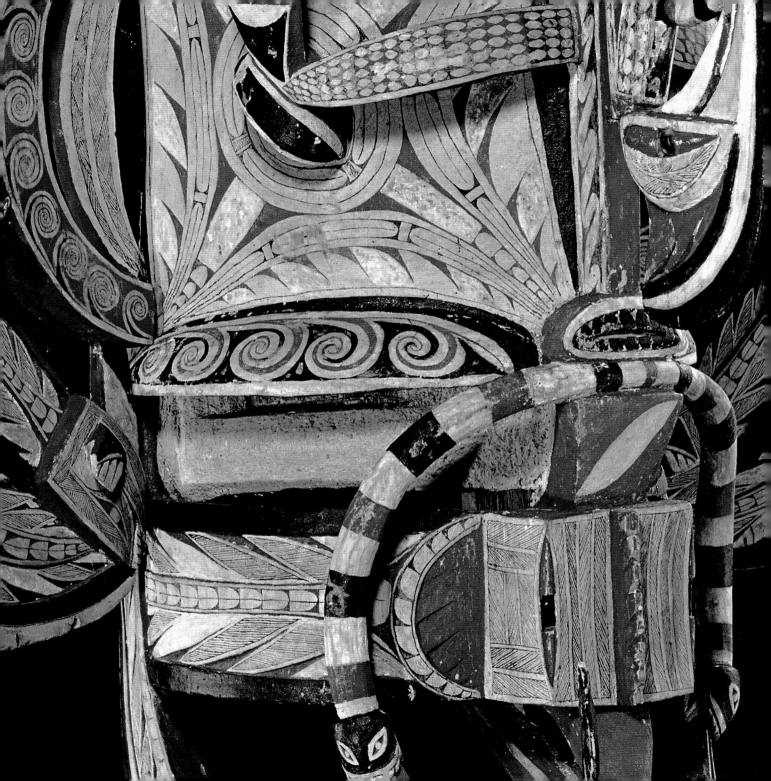

6

Art of Power

The objects in this chapter are full of potency and pride. They declare their owners' excellence and social status – as leaders, spiritual authorities or possessors of knowledge or wealth. Worn or held, these adornments and treasures can be seen to act in a similar way to a European monarch's crown, a bishop's mitre, a mortar board and gown, or a blaze of diamonds.

As the objects in this chapter demonstrate, the art of power in the Pacific has not just been about demonstrating authority, but about managing the connection between authority and ancestral power (often known as *mana*). Some things, such as the heavy feathered cloaks of Hawaiian leaders, were worn to set them apart from commoners and make apparent the connection of the wearer to higher, divine beings. Everything that came in contact with the powerfully sacred chiefs of the eastern Pacific was designed to manage the *mana* that travelled down a hereditary line from the original gods of creation. Wrapping chiefs in cloth and cloaks, or providing them with appropriately designed containers to hold food and other profane substances, protected their power from desecration.

The makers of the objects of power in this chapter were usually men, but women have also created and managed their own forms of regalia and other potent markers of status. The power of women and the power of men were often seen as sitting in opposition. Roles and rituals could be strongly segregated (men's houses, for instance, embodied an exclusion of female power), although authority is now

more evenly shared.

The social and material power of wealth has historically been held, exchanged and displayed through a wide range of valuables. While cash has taken over many of these roles, some traditional forms continue. In the western Pacific valuables included shells worn on the body, strings of shells carried on ritual occasions or lashed onto the prow of a canoe for display and trading. In order to retain their value, the heavy rolls of glossy feather money in the Santa Cruz Islands in the Solomons had to keep their brilliant red colour, so they were stored carefully wrapped in leaves in houses until needed for a wedding or other exchange. In Yap in Micronesia, huge discs of stone carved with a central hole were a form of currency that changed hands only rarely. Across the Pacific, pigs were and often still are an important form of wealth, necessary to establish one's authority or to make it possible to stage a coming-of-age ceremony or a wedding. Wealth in the eastern

Pacific was carried through food, barkcloth and sacred objects such as bundles of red feathers and specialist goods (drums, canoes, and raw materials) that were traded between islands.

Ceremonial sword (*brotech*).
Belau (Palau), *c*.1783.
Wood, shell or shark's teeth. L. 81cm. W. 7.8 cm.

In Belau, northwestern Pacific, in 1783, a carver made a new type of status object for a new type of visitor. When a British East India Company vessel had wrecked on a reef off Koror, Belau, the island's *Ibedul* (chief) and his people helped Captain Wilson's crew to build a new boat. In return, the crew supported the *Ibedul* in his attacks on nearby islands. This ceremonial weapon could have been modelled on one of the officer's swords – if so, it was an object reflecting both cultures, as those giving it called it a *brotech*, a local paddle-like weapon.

When Wilson was ready to set sail, the *Ibedul* gave him this *brotech*, along with a large bird-shaped tureen, bowls of turtle shell, currency beads, and other items of prestige. The *Ibedul* also sent his son Lebuu so he could learn about Britain and the broader world. Lebuu had a fascinating journey, but like other visitors from beyond Europe, he died of smallpox before he could return home. Wilson's family bequeathed the gifts from the *Ibedul* to the British Museum in 1875.

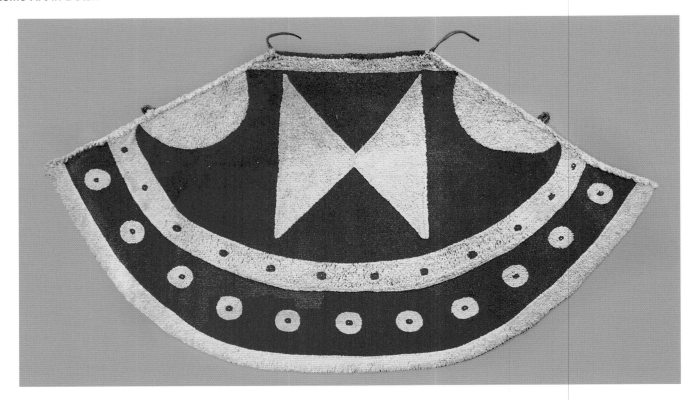

Chief's feather cloak ('ahu'ula).
Hawai'i, 1700s.
Olonā fibre, feathers of honeyeaters and
honeycreepers. ('i'iwi, mamo,ō'ō) W. 259 cm.

This sumptuous cloak is made of some half a million feathers from small Hawaiian birds. High-ranking specialists in the sacred practices of collecting and weaving feathers made this cloak for their chief. The feathers were bound into tiny bundles and knotted into a dense netting of olonā vine fibre (see right). The feathered surface feels like velvet.

Cloaks were handed down through generations, or given as gifts to secure political allegiances. Chiefs (ali'i) traced their lines of descent from the gods of creation. Many of these gods were linked to birds; birds could fly between and connect the realms of the living and the divine. The shape and wing-like designs of the cloaks made clear an ali'i's close connection to feathered gods, while red and yellow feathers were seen to attract the gods' positive attention.

Worn in battles, a cloak such as this proclaimed the ali'i's presence and gave spiritual as well as some physical protection from attack. This cloak is thought to have belonged to Kahekili, the chief of Māui. Records of the first visit of Europeans to Hawai'i in 1778 describe a respectful exchange between Kahekili and Captain Cook's second-in-command, Charles Clerke, during which the ali'i presented two of these intensely potent cloaks.

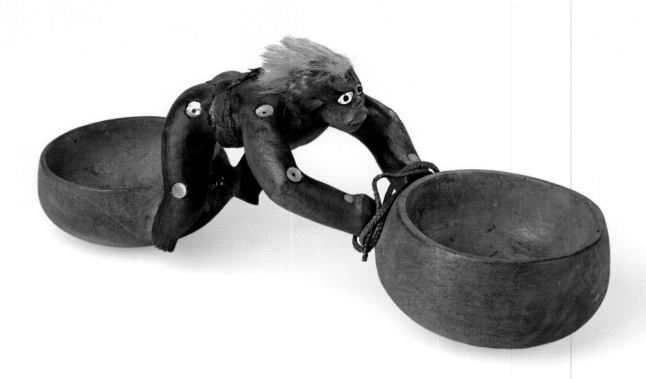

Chief's food bowl.

Hawai'i, 1700s to early 1800s.

Kou **wood, feathers, dog fur, pearl shell.**

L. 27.9 cm. W. 9.8 cm. D. 11.5 cm.

Made by a specialist carver for the exclusive use of an *ali'i* (chief), this pair of bowls is linked by a dynamic figure with hair of highly sacred red feathers and dog fur. The chiefs of the central and eastern Pacific took care when approaching cooked food, considered a profane substance. A range of *tapu* (taboo) items safeguarded those of divine lineage from coming into inappropriate contact with cooked food. Bowls for food were managed by their own attendants, who carefully disposed of the *ali'i*'s scraps to avoid them being used against him in sorcery. Carvers created figures of entertaining acrobats and of subjugated chiefs, forever bent in service. The carver would shape the form with adzes and chisels, then polish with pumice, shark's skin, sand and rough leaves, before applying a finish of candlenut oil. Inlaid pearl-shell discs mark the figure's eyes and joints.

Bowls for disposing of a chief's food scraps could be inset with the teeth of slain enemies, as an ongoing insult to the defeated.

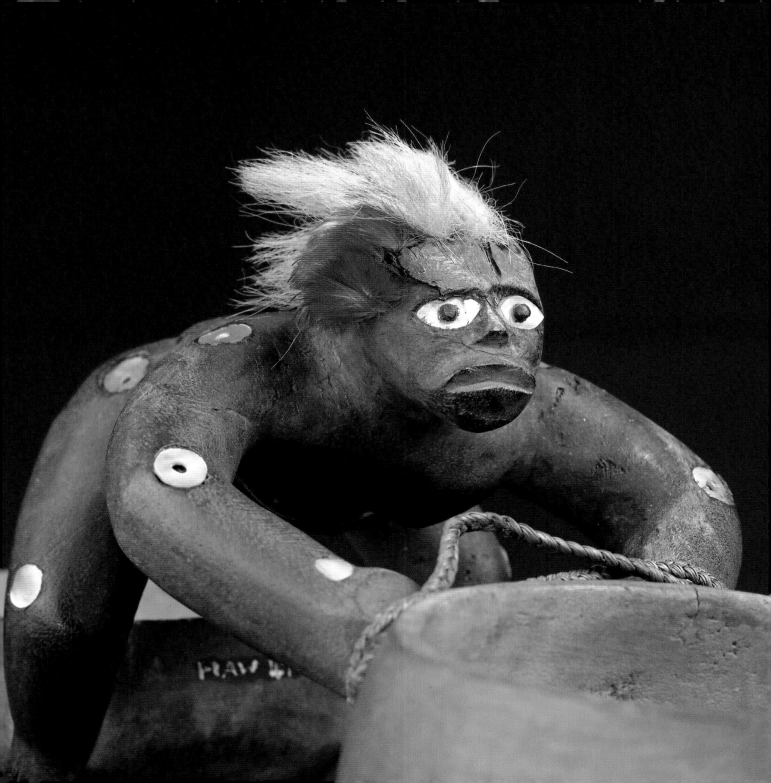

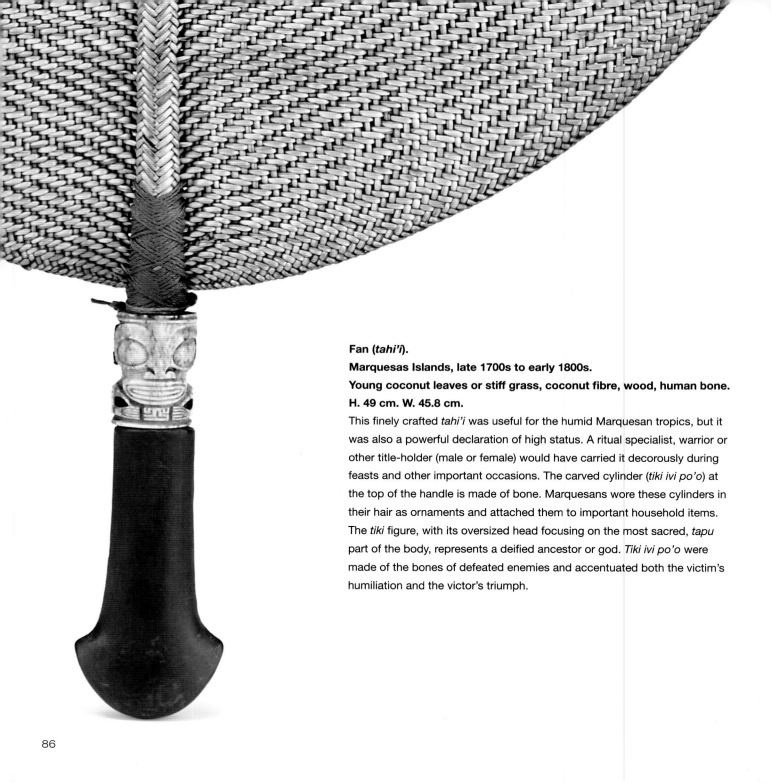

Fan (*tahi'i*).
Marquesas Islands, late 1700s to early 1800s.
Young coconut leaves or stiff grass, coconut fibre, wood, human bone.
H. 49 cm. W. 45.8 cm.

This finely crafted *tahi'i* was useful for the humid Marquesan tropics, but it was also a powerful declaration of high status. A ritual specialist, warrior or other title-holder (male or female) would have carried it decorously during feasts and other important occasions. The carved cylinder (*tiki ivi po'o*) at the top of the handle is made of bone. Marquesans wore these cylinders in their hair as ornaments and attached them to important household items. The *tiki* figure, with its oversized head focusing on the most sacred, *tapu* part of the body, represents a deified ancestor or god. *Tiki ivi po'o* were made of the bones of defeated enemies and accentuated both the victim's humiliation and the victor's triumph.

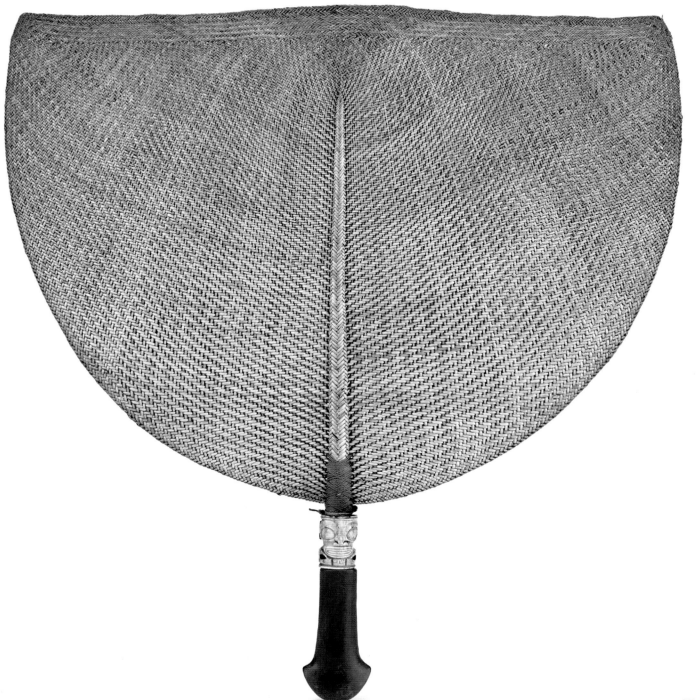

Lime spatula and money holder. Louisiade Archipelago, Papua New Guinea, before 1847. Turtle shell, fibre. L. 23.5 cm. W. 12.3 cm

This complex object was a symbol of rank, a mode of displaying wealth and a spatula for scooping powdered lime out of a gourd container. People of the Louisiade Archipelago, Papua New Guinea, have a long history of chewing lime mixed with 'betel nut' (areca nuts and betel leaf) as a stimulant.

The spatula's form symbolizes several things. When the blade points downwards, it represents a human: either a human head, with two frigate bird heads standing for the eyes and the plain, curving band the forehead; or, alternatively, the whole body, with the long projection standing for a leg or phallus. When it is held the other way up, the form represents a boat. The holes along the top of the crescent allowed strings of ritual currency to be threaded through. This currency was made of small discs of pink and orange *Spondylus* oyster shell to be attached to the spatula with fibre. Displaying such wealth, the spatula was transformed into a powerful ritual object.

Women's grade textiles.
Banks Islands, Northern Vanuatu, 1800s
or early 1900s. Pandanus leaf fibre.
L. ranging from 62 to 97 cm.

Women of the Banks Islands wore these
waistbands to indicate the rank they had
achieved in their ritually graded societies. They
were made by women, plaited from finely-split
pandanus leaf. Stencils of images were placed
on the strips which were then wrapped and
lowered into dye. The completed bands were
worn tied in front with tassels hanging down. On
the nearby island of Ambae, a legend tells of the
first band (*tupeki*) worn by the fully tattooed wife
of Tagaro, the creator god. Wearing the *tupeki*
– and nothing else – showed her tattoos in their
full glory.

An advocate of women's cultural practice,
Jean Taresesei from Ambae, has said: 'Grade-
taking mats are different to money mats. They
are small and the patterns are more important
in grade-taking mats. We have to pay for the
rights before we can use these patterns. When
you wear one of these mats, it indicates that
you have been doing certain things in *kastom*
ceremonies.' (Vanuatu Cultural Centre, *c*.2005).

A woman taking a grade needs to marshall
social and economic resources including food,
pigs and valuables. In northern Vanuatu, women
wear larger dyed mats wrapped around the hips.
These dyed textiles can indicate clan affiliation.
On Ambae women continue to make textiles that
declare the status they have achieved.

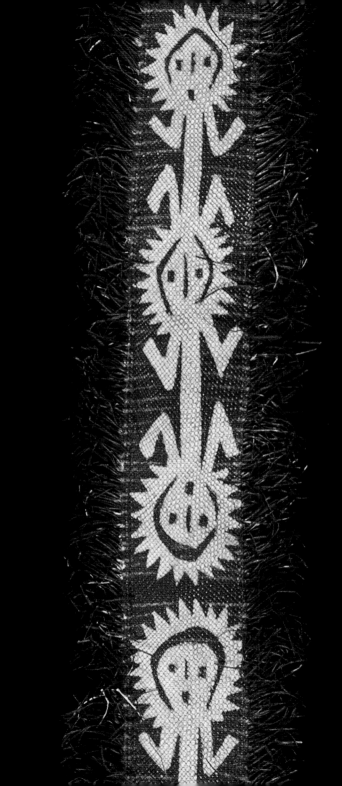

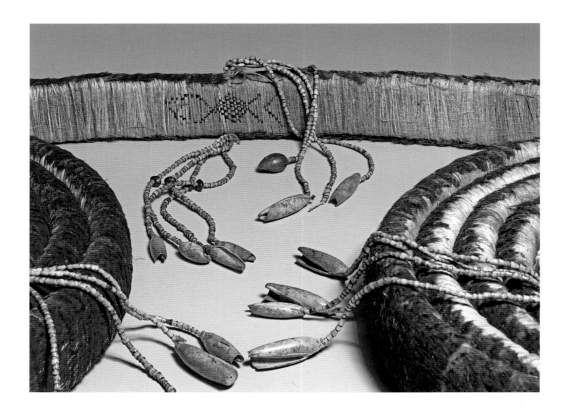

Feather money (*tevau*), made by Mekimo of Naipe Village, Noipë. Santa Cruz Islands, within the Solomon Islands, *c.*1975. Honeyeater feathers, pigeon feathers, plant fibre, shell. L. 1,064 cm. H. 5.5 cm.

This sumptuous reel is a particularly beautiful form of currency. It is *tevau*, feather money, made of tiny red feathers from the scarlet honeyeater. Until the 1980s, *tevau* was used in the Solomons for payments made to a woman's family on her marriage. It was also presented to high-ranking men, and could buy high status items such as pigs and canoes. Hereditary specialists in feather gathering and binding

made *tevau*. They were said to receive their skills from spirits. A double coil such as this one could use 50,000–60,000 red feathers. The red feathers were tied to larger grey pigeon feathers, which were easier to weave into the plant-fibre base. The resulting platelet was attached, overlapping the previous platelet and gradually building up from the midpoint. The shell tassels and dark fibre motif at the midpoint had ritual significance. The brighter the *tevau*, the more value it held.

While cash has replaced *tevau*, some islanders are hoping to revive its cultural and economic importance.

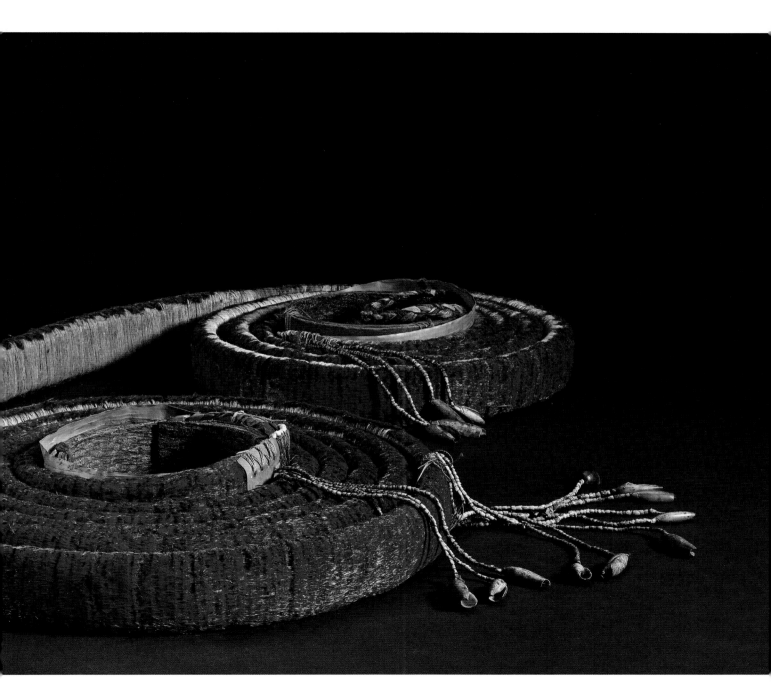

Leader's mortuary mask.
New Caledonia, probably before 1853.
Wood, human hair, fibre, feather, bark,
bamboo. H. 66 cm. W. 45 cm. D. 36 cm.

This mask from New Caledonia represents a chief. It is adorned with hair, probably from the men mourning the chief's death. In the north of New Caledonia, a chief's mourners wore masks such as this during his mortuary ceremony. The symbolism of the mask made connections with the underwater world of the dead. The performer wore the mask high (looking out from the mask's mouth, rather than the eyes), covered himself in a cloak of black feathers, and hit out at the assembled people with clubs. The chief's abiding power was underlined in these ceremonies.

The explorer Jacques-J.H. de Labillardière first recorded these masks in 1792. When missionaries met the Kanaks (the indigenous people of New Caledonia), they thought the masks were representations of devils and tried to stop their use. Few were made after French colonization in 1853. More recently, people have been including these masks in mourning rituals as part of a resurgence of Kanak traditional practices. The masks have also been incorporated into local Christian practice.

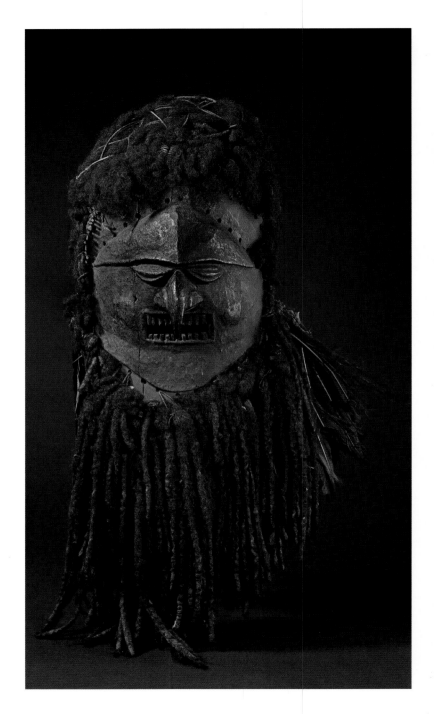

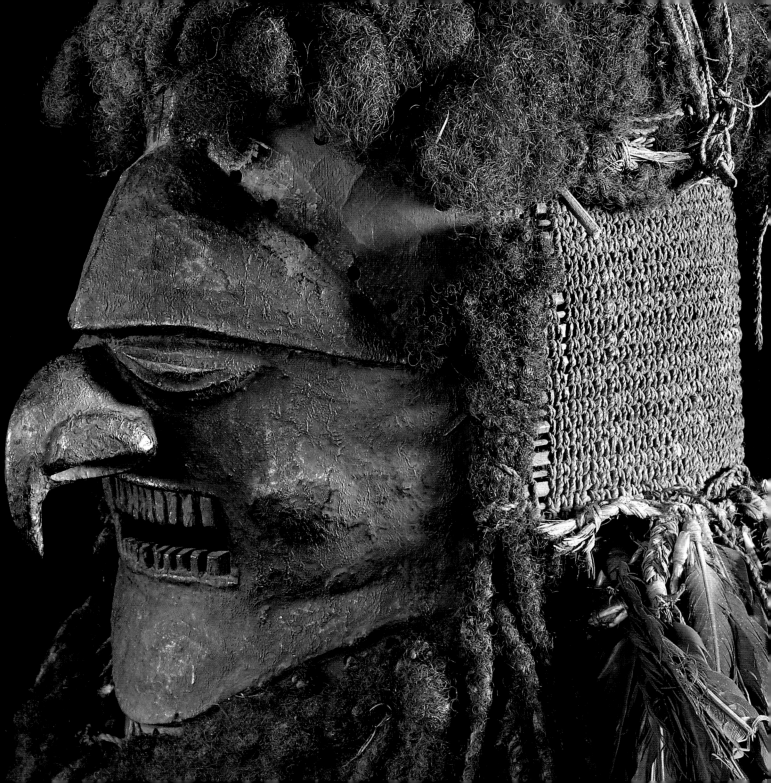

Chief's loin cloth.
Fais Island, Yap State, Caroline Islands,
late 1800s–early 1900s.
Banana and hibiscus fibre.
L: 186 cm. W: 29 cm.

In the low coral islands to the east of Yap there is a long tradition of women weaving finely-patterned textiles made of banana leaf fibre and hibiscus bast fibre on back-strap looms. Fais islanders consider these cloths (*machi*) the most precious objects produced on the island. In pre-Christian times these textiles were sacred and were worn by chiefs as loin cloths or ceremonial sashes. The Re-Mathau (People of the Sea) had an alliance with the well-resourced high island of Yap, and, every few years, would carry *machi* and other tribute payments in fleets of outrigger canoes to the Yapese chiefs. In return, the chiefs would leave them in peace, and reward them with foods, spices, pots, and other items unobtainable in the outer islands. Tribute payments ended in the 1920s when the Japanese colonial government banned long-distance canoe travel.

These textiles retain much of their traditional value and are still worn by men as loin cloths and by women as wrap-around skirts. Since World War II weavers have been creating designs with the new colours of commercially-dyed nylon and cotton thread. After a period of hiatus older women have recently resumed teaching younger women the art of weaving *machi*.

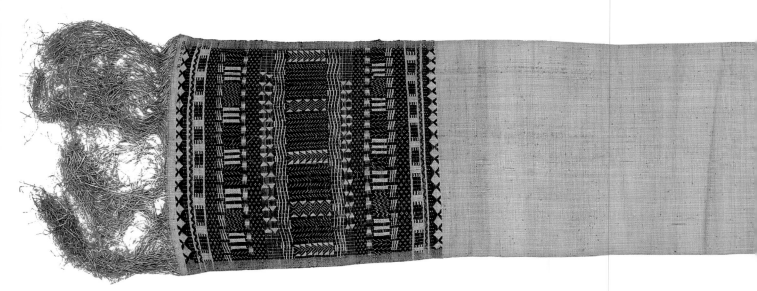

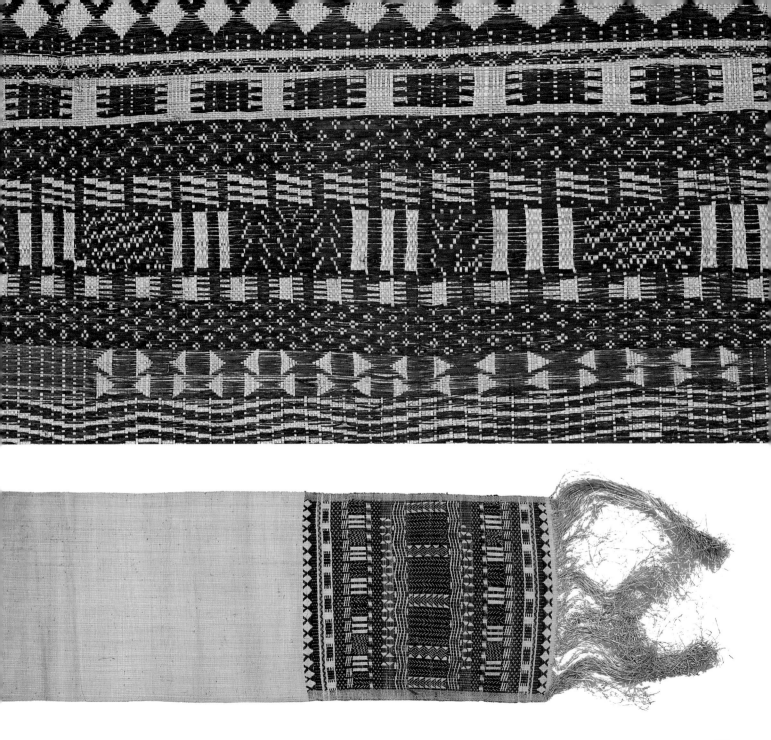

7

Art of Dance

Dancing is an expression of the heart … that is what dancing is. It is your feeling, your heart's feeling, your emotions, everything. It is the whole of your body.

Gina Keenan-Williams, Orama dance group, Cook Islands, 1997

With swirling costumes, rapid drumbeats, loud calls, harmonic songs and spoken words, the performing arts of the Pacific are a vibrant and vivid part of life. They are also an intimate part of the everyday. As an anthropologist of dance, Kalissa Alexeyeff, has said: 'Cook Islanders consider performing arts to be something "you just do" … Young children are constantly being bounced on the knees of adults to the rhythm of various drumbeats…. Most households [have] a guitar or ukulele, and everybody sings.'

Dance, music, song and oratory are integral to daily, ceremonial and religious life across the Pacific. These modes of performance have a long history of creating connections to people, gods and ancestors. They have more recently taken on additional meanings as expressions of national and cultural identity. Pan-Pacific dance competitions have, in recent decades, underlined the identification of particular performance styles with specific nations. As anthropologist Adrienne Kaeppler has said, the Festival of Pacific Arts, regularly bringing islanders from all corners of the ocean together, is 'in fact, a ritual renewal of what it means to be a Pacific Islander' (2002).

Dances and stories are handed down, as heirlooms, from generation to generation. But there is also space for innovation. Aunts and cousins at a weekend gathering might ad-lib with steps they have seen and danced from the time they could first stand, holding

Tumata Robinson's Tahiti Ora dance group (see page 100), on tour in Japan. Kobe, November 2010. © Ishi Enterprize, Inc. /Katsu.

Dance bracelet. Hawai'i, 1700s to 1800s. Boars' tusks, olonā fibre. H. 10 cm. W. 16.5 cm. Worn by male dancers on their wrists, these graceful bracelets evoked the masculine power of boars, an animal with powerful links to major deities.

a grandparent's hand. Improvising with the traditional movements can add fun or a joke within this physical language. For professional dance troupes and avant-garde performers – the Samoan choreographer Lemi Ponifasio, for instance – innovation and its intersection with historical forms creates the backbone and dynamism of their practice.

Christian missionaries arriving in the Pacific were unnerved by the exuberant, sensual nature of islanders' existing dances as well as performances that made fun of the strait-laced newcomers. In most places, as soon as missionaries worked their way into positions of authority, supported by local leaders, they banned or restricted dance.

Dance often became clandestine. More recently, particularly from the 1970s, a broad cultural and political renaissance has occurred across the Pacific, reviving an interest and pride in the 'Pacific way'. Dance and other performing arts have flourished.

Within the great range of dance styles across the Pacific, one of the constants can probably be said to be the 'groundedness' of the dancers, a solidness of the dancers' steps, many of the moves bent-kneed, giving a feeling of being connected to the land. There are seated dances in islands such as Kiribati, Tuvalu, Samoa, Tonga and Hawai'i, where songs and poetry are interpreted through symbolic moves of the arms, hands and the upper body. Reflecting a narrative through movement is another pervasive feature of Pacific dance.

Other performance arts convey narratives more overtly. Master orators recount stories of events of gods and ancestral heroes, recite genealogies, and perform ceremonies of welcome for visitors. Ceremonies often combine dance and drumming, the music of flutes, the sound of conch shell trumpets, rattles, bullroarers, clapping, calling and singing. Contemporary performers bring in instruments, moves and voices from beyond the Pacific, creating new genres such as Jawaiian reggae and Pasifika hiphop, continuing the tradition of change while retaining a distinctly Pacific identity.

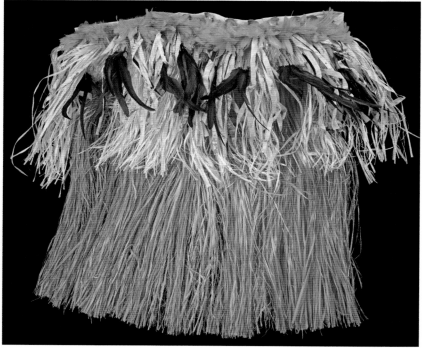

Tumata Robinson, woman's dance costume. Tahiti, 2003. Shell, hibiscus fibre, pandanus fibre, feathers, cotton, barkcloth, cardboard. TOP LEFT **Headdress. H. 64 cm. W. 48 cm.** BOTTOM LEFT AND RIGHT: **Skirt. L. 103.6 cm. H. 99 cm. Belt: L. 105 cm. H. 51.5 cm.**

Tumata Robinson, director of one of Tahiti's main dance troupes, made this costume. Tumata started her first dance group when she was nineteen, during the revival of traditional art forms in the mid-1970s. Throughout her career, Tumata's choreography and costuming have blended traditional styles with innovative new approaches. She has drawn criticism from cultural 'purists', but creative freedom has always been important to Tumata. She says, 'The idea of dance as a profession, as something with artistic value, is still pretty new here.'

Dance troupes in Tahiti (French Polynesia) compete in local and international competitions, and perform at hotels and in the annual *heiva* in July, a festival of dance, song, sports and canoe races. When first described by Europeans in the 1700s, Tahitian dances were not only for entertainment, but also for the gods, performed by a class of religious elites. When missionaries suppressed it, the Maohi (indigenous Tahitians) danced clandestinely, continuing to teach children the forms. Dance is a pervasive part of life in the island and a vibrant part of Maohi cultural identity.

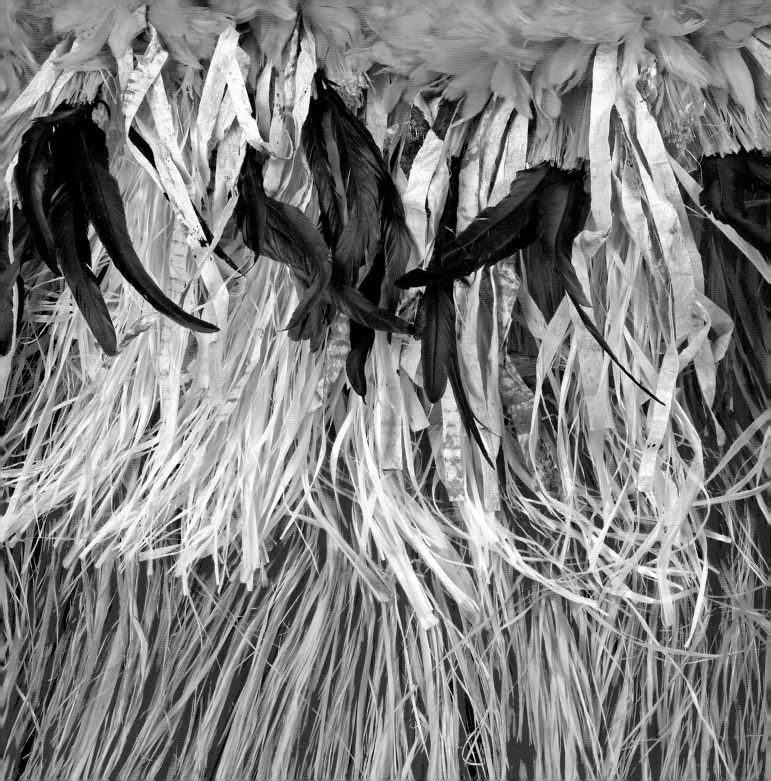

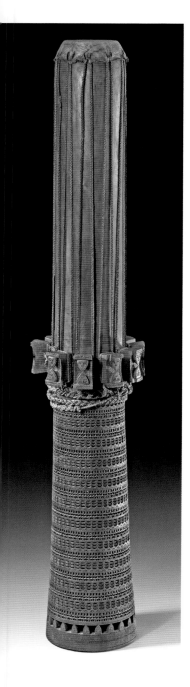

Drum (*Pahu rā*).
Ra'ivavae, Austral Islands, early 1800s.
Wood, shark skin, coconut fibre.
H. 131 cm. D. 26.6 cm.

The intricate, minutely symmetrical carving on the base of this drum is typical of the Austral Islands. The design includes rows of dancing women, female figures with their arms and legs meeting. Drums and similar percussion instruments have always provided a major part of the music for dancing, rituals, and religious ceremonies in the Pacific Islands. Ranging from small Hawaiian drums that rest upon the knee to huge slit-gongs carved from whole tree trunks in Vanuatu and New Guinea, these instruments continue as a distinctive feature of performances in the Pacific today.

This type of standing drum was highly sought after in the Central Pacific and, despite the distances involved, they were traded from the Australs to Tahiti and probably beyond. Men played them at *marae* (temple sites) during ceremonies, providing the 'voice of the gods', and marking the start and conclusion of sacred rituals.

Once the sharkskin was stretched over the top of the drum, it was lashed down evenly with plaited coconut fibre cord wrapped around lugs. The lugs were carved with paired faces and, continuing the population of the drum's surface, tiny faces can also be seen between each lug. Only about dozen of these early drums survive.

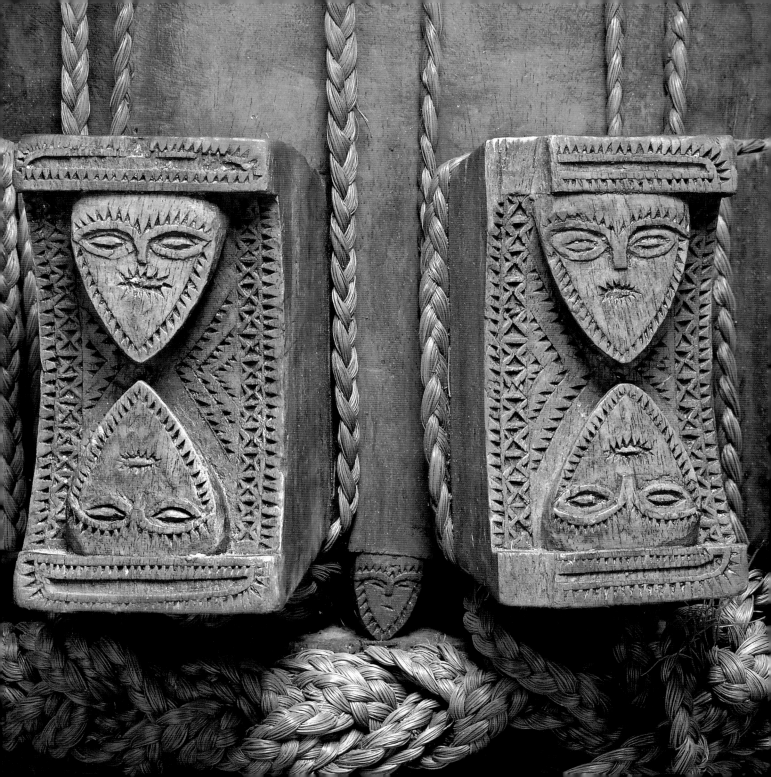

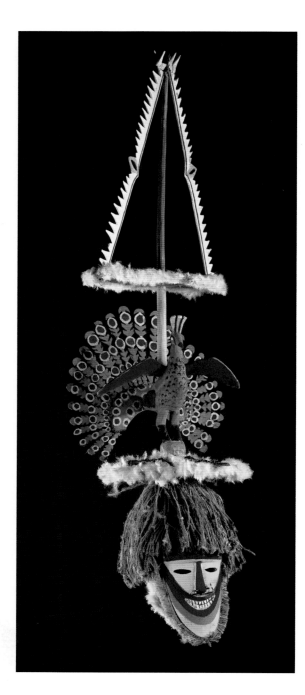

**_Lor_ dance mask made by Luk Linat.
Gazelle Peninsula, New Britain, 1995–97.
Wood, barkcloth, woven bark fibre, glass,
feathers, paint. H. 123 cm. W. 50 cm.**
This cheerful, exuberant mask is for a _lor_ 'spirit'
dance. The Tolai people of New Britain (a large
island north of New Guinea) perform humorous
dances wearing masks representing spirits or
'not quite human' characters. _Lor_ means 'skull'
in several of the languages of the region. While
this mask does not contain any actual skull
fragments, some historic examples had over-
modelled portions of human skull as the basis
of the mask.

Luk Linat chose a showy peacock for
this mask, all part of its entertainment value.
Peacocks may not be a traditional feature of
Tolai life, but Linat has employed historic forms
for the mask's face and structure. The Tolai say
that _lor_ dances (also called _alor_, or _lorr_) used
to represent a bearded man of the bush. His
appearance in a village at the start of an initiation
heralded the arrival of dangerous masked _tubuan_
spirit figures, who subjected the young men of
the village to painful trials.

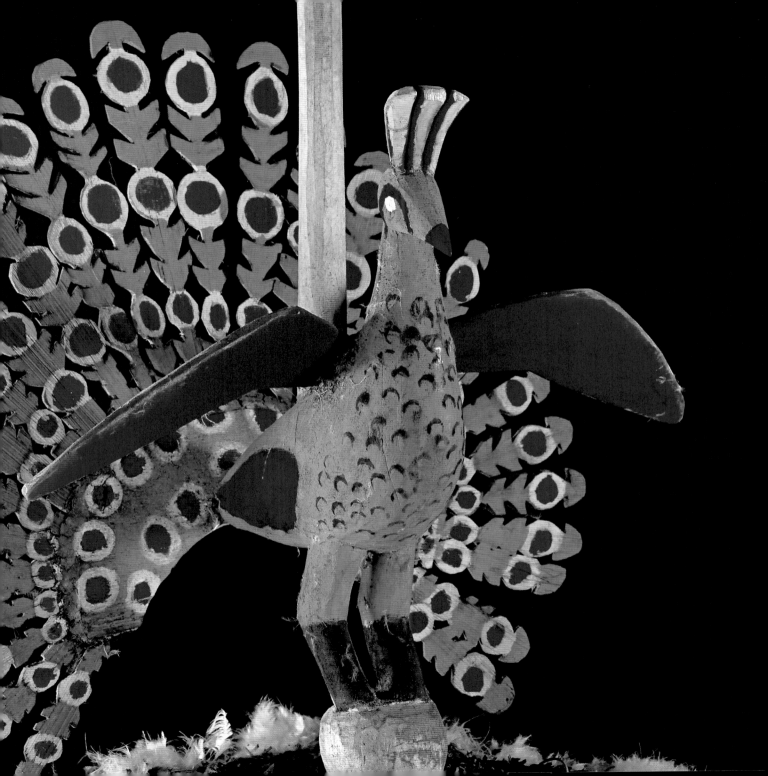

Headddress.
Mekeo region, Central Province, Papua
New Guinea, before 1970s.
Parrot and bird-of-paradise feathers, bailer
and nassa shells, dog teeth, seeds, plant
fibre, glass beads. H. 96 cm. W. 99 cm.
The Mekeo people are well-known for their
spectacular feathered dance headdresses.
The Mekeo live in a region west of Papua New
Guinea's capital, Port Moresby. Headdresses
such as this are worn with the dancer's face
painted – usually yellow with red and black
accents, and adorned with earrings and nose
ornaments. Mekeo dancers often feature
in representations of Papua New Guinea,
appearing on book covers, stamps and tourist
brochures. Daniel Waswas' painting of a Mekeo
dancer's face and headdress has recently been
embedded in the three-storey glass façade of a
major company building in Port Moresby.

The most prized elements of the headdress
are the red tails of the Raggiana bird-of-paradise.
These are an important form of wealth. The large
bailer shells overlaid with finely carved turtle-
shell designs are valuable ornaments, known as
kap kap (an equivalent from the Solomon Islands
is on page 92). The headdress is heavy and the
curving support, decorated with nassa shells
and loops of trade beads, would have helped
the dancer to manage the weight and keep the
headdress in place. The coloured glass trade
beads are an example of the way in which artists
use foreign materials to enhance the aesthetic –
and thus the social – impact of their works.

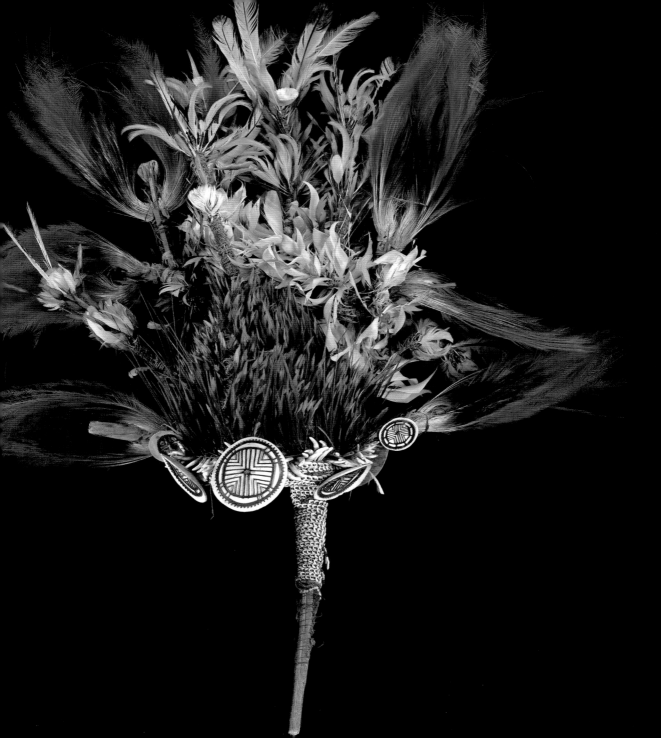

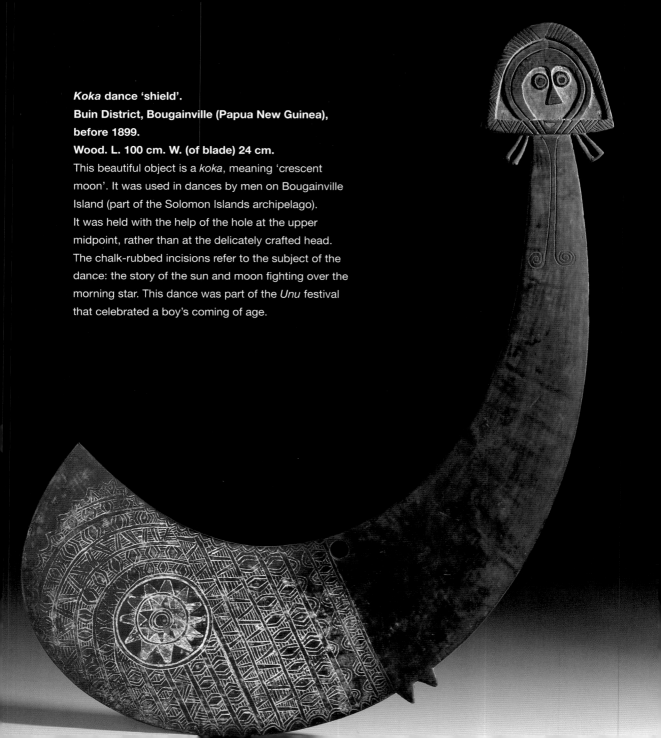

***Koka* dance 'shield'.**
Buin District, Bougainville (Papua New Guinea),
before 1899.
Wood. L. 100 cm. W. (of blade) 24 cm.
This beautiful object is a *koka*, meaning 'crescent
moon'. It was used in dances by men on Bougainville
Island (part of the Solomon Islands archipelago).
It was held with the help of the hole at the upper
midpoint, rather than at the delicately crafted head.
The chalk-rubbed incisions refer to the subject of the
dance: the story of the sun and moon fighting over the
morning star. This dance was part of the *Unu* festival
that celebrated a boy's coming of age.

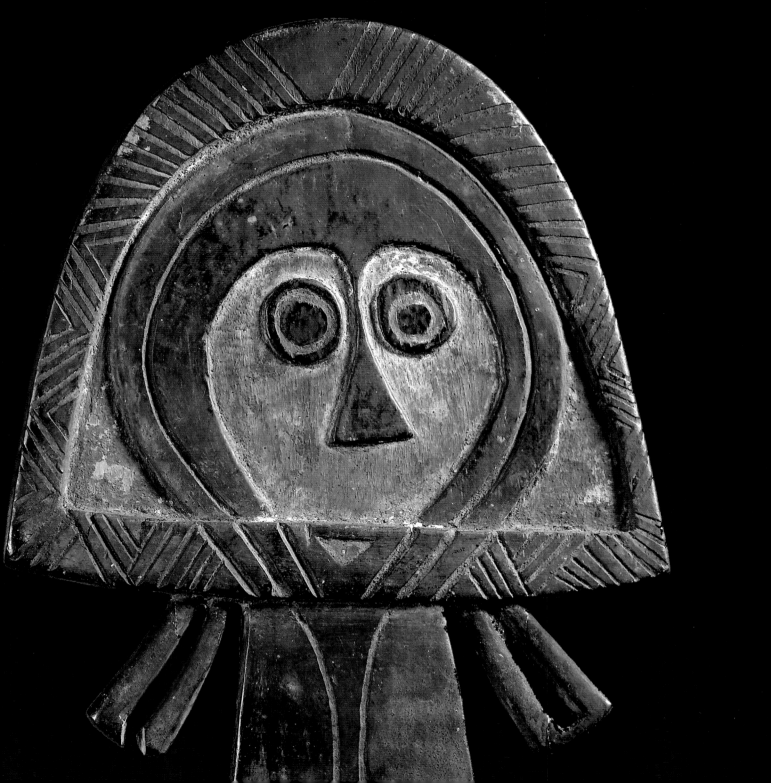

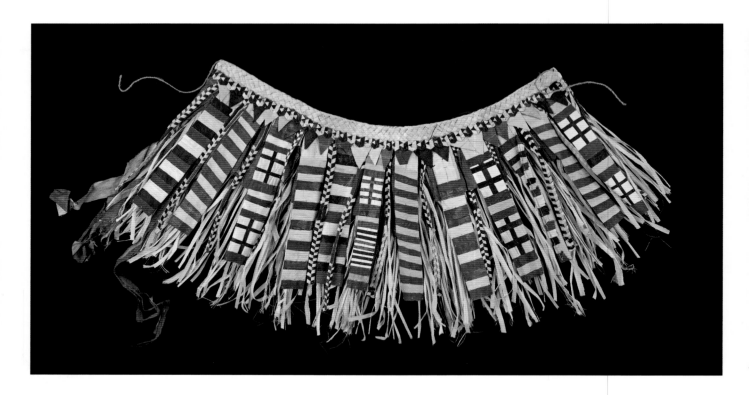

Dance skirt.

Nukulaelae atoll, Tuvalu, 1950s.

Pandanus leaf fibre. H. 48 cm. W. 85 cm.

This dance skirt was made in Tuvalu, a chain of atolls in the central Pacific. A British colonial officer acquired it in 1957. Skirts such as this are still worn in dances today. The brightly painted strips and patterned plaits rustle and move to vibrant effect as the dancers sway. Tuvalu dance emphasizes both seated and standing ensemble performances, with both men and women participating. All the performers wear lush coronets of flowers and leaves.

Practising cultural traditions such as dance is charged with a particular significance in Tuvalu. Being extremely low-lying, the atolls are already being inundated by increasingly high tides, and the country is predicted to be among the first to disappear as a result of sea-level rise.

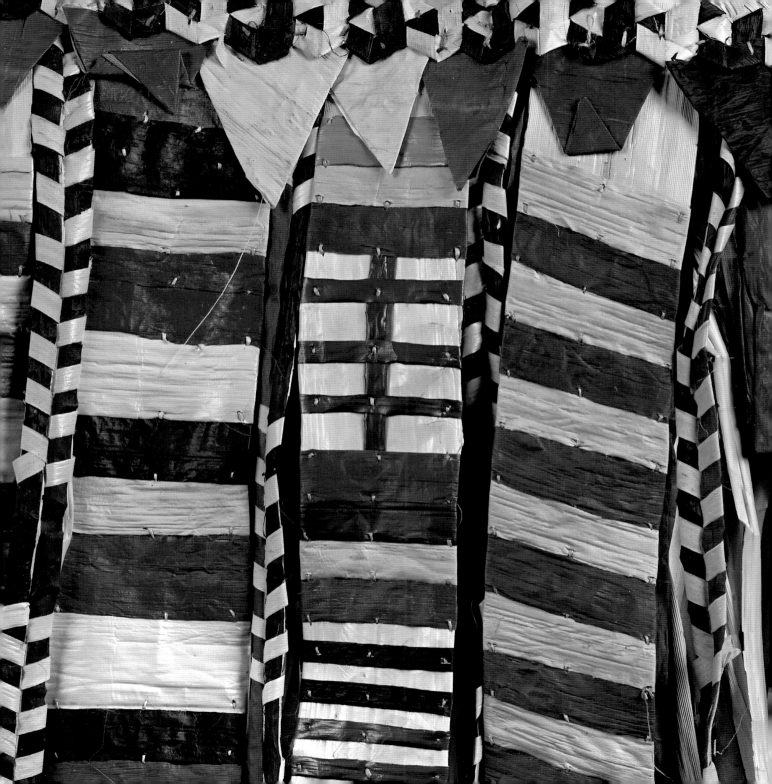

8

Art of War

Kui'ailuna,	Smite upwards
Kui'ailalo . . .	Smite downwards . . .
Lame'a ka hanu i paukeola.	Take the breath and quench the life.
A pa ia oe a pa ia'u	You strike and I will strike also.
Amana – ua noa.	The petition is offered – the taboo is lifted.
Lele wale aku la.	The prayer takes flight.

Hawaiian chant, from *Lua: Art of the Hawaiian Warrior*, 2006

Wars, assassinations, headhunting raids, hand-to-hand combat, and canoe battles at sea were once all a part of life in the Pacific Islands. Warriors trained in martial arts and designed their costumes, weapons and shields for maximum intensity, to frighten, intimidate and disorientate the enemy.

There are a few places where local forms of warfare continue. The Papua New Guinea Highlands are renowned for intense and frequent interclan battles. The 'South-Pacific Lager' shield featured on page 112 is from one of these recent conflicts. Of course wars have been fought in the Pacific on a broader scale, too. It was not just trained soldiers who were caught up in the battles of World War II – and in military coups, and struggles for independence from colonial rule – but civilians, too. For the most part, museum collections contain only historic

material from past warfare in the Pacific. A considerable number of the spears were collected after islanders had thrown them at unwelcome Europeans. Many hand clubs, fighting staffs and shields were collected when craftsmen started making versions for visiting foreigners, and others were traded away when the active need for them had ebbed away. Changes to indigenous political, social and economic systems, accompanying the conversion to Christianity, then colonial governments, undercut the cultural roles of warriors. Conflicts lost their raison d'être – when the land was held by outsiders, and when control over the marks of power had been wrested away, many of the reasons to stand by what was once at the centre of a society had gone. In places such as the Solomon Islands, the British authorities punished any community that persisted in going on headhunting raids by setting fire to their villages and shooting their leaders.

Pacific warriors used to fight not only over territory, or to consolidate their leader's power, but also to make revenge killings or as part of a male rite of passage.

Breastplate (*civavonovono*). Fiji, c.1820–1840
Whale ivory, shell, coconut fibre, metal. Di. 20 cm.

Tongan canoe builders living in Fiji, would have made this impressive *civavonovono* for a Fijian chief. This kind of composite breastplate (of precious whale ivory and shell) was based on earlier plain pearl shell breastplates worn in Fiji and Tonga. It is a sign of status. *Civavonovono* covered only a hand-sized portion of the chest, but chiefs still wore them into battle. They were considered to provide supernatural protection. The dark centre of this breastplate is made of iridescent pearl shell, and features a star motif common in Tonga. The earliest examples are bound together by the canoe-builders' neatly hidden lashings. Later ones, such as this, make use of metal rivets, obtained in trade with Europeans.

Most warriors were men; but there were women warriors in many Pacific societies. Some women went to battle and became individual fighters of renown, while others contributed to the ranks of soldiers, pelting their opponents with stones and engaging in close combat with the women on the enemy's side. Māori women and children learned martial arts in order to defend themselves and their houses.

This chapter showcases a selection of warrior's tools. As you will see, these were often crafted to mesmerize and unnerve the enemy, employing what anthropologist Nicholas Thomas calls an 'aesthetic of intimidation'.

Kiribati warriors in armour, posing with lances. Photo: A. Kramer, Hawai'i, Ostmikronesien und Samoa, Stuttgart, 1906. National Library of Australia, Canberra.

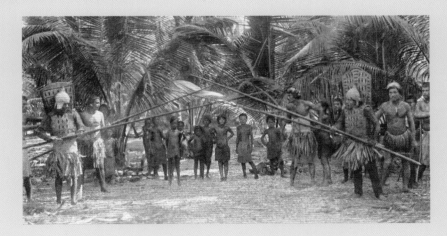

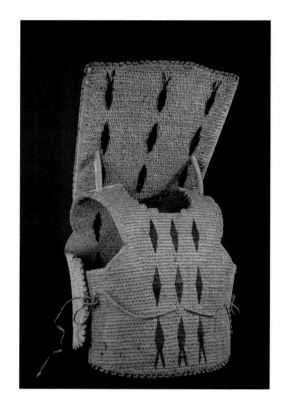

Shark-tooth weapon, helmet and cuirass. Kiribati, probably 1800s. Weapon (*te unun*): wood, shark's teeth, coconut fibre, human hair. L. 83.8 cm. W. 30 cm. Helmet (*te barantauti*): porcupine fish (*Cyclichthys orbicularis*), coconut fibre. H. 37.5 cm. W. 31 cm. Cuirass (*te tana*): coconut fibre, human hair. H. 85 cm. W. 45 cm.

Kiribati warriors were known for their ferocity. They also had the most fully developed armour in the Pacific: a thickly plaited suit of armour of rough coconut fibre, the spiny skin of a dried porcupine fish as a helmet, and a heavy cuirass with a raised backboard to guard against blows from behind. In Kiribati (pronounced 'kiri-bus'), wars were often fought over an insult, or over territory. One of the most violent was the religious war of 1881, in which Christians of the north turned the non-Christians of the south off their land.

The stylized fish motifs on the cuirass are woven of human hair. The barbs on the weapon are shark's teeth, each one drilled with two holes and bound onto the wood with fine coconut fibre.

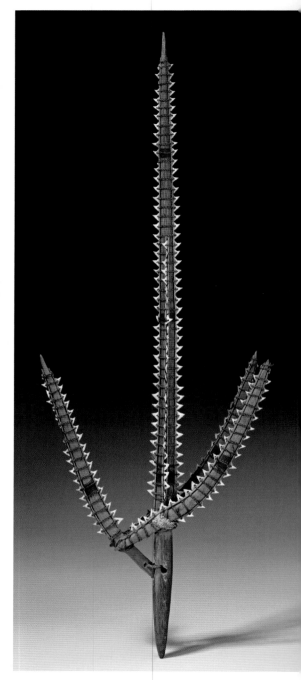

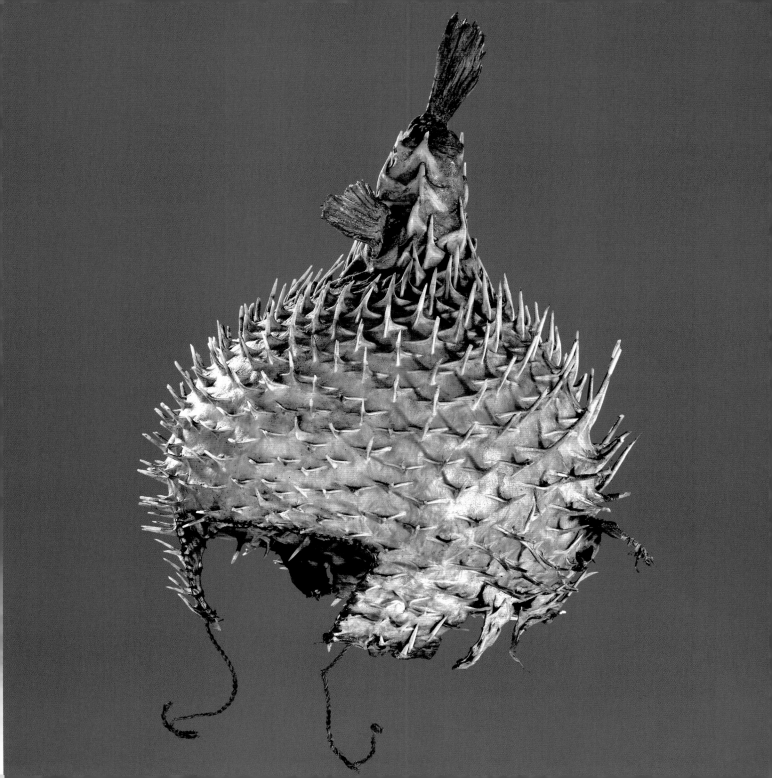

Shield (named Pokor), by Par.
Sauwa-Eema village, West Papua, Indonesia, 1960s.
Wood, pigments. L. 171 cm. W. 50 cm.

When an Asmat man of West Papua carries a shield into
battle, he knows that he is protected not only by the heavy
mass of wood, but also by the power of the ancestor
connected to the shield. A shield is cut from a mangrove
plank root, carved, painted and named after the selected
ancestor. This shield, dating from the 1960s, was named
after the carver Par's deceased father, Pokor, and features
a flying-fox motif in the centre. Fruit-eating birds and
animals were potent symbols of headhunting and are often
included on shields, as people were thought of as trees,
with the head being the fruit. This shield is also bordered
by motifs symbolizing shell nose-ornaments and topped
by *wisir kus*, the head of a ray fish. Shields are often
displayed during feasts, and the greater number a village
possesses, the more powerful the village feels.

Headhunting is no longer practised in the region;
carvings are now primarily produced for sale, bringing the
village important funds. This one was purchased in 1968
through the United Nations-supported Asmat Handicrafts
Project, in West Papua.

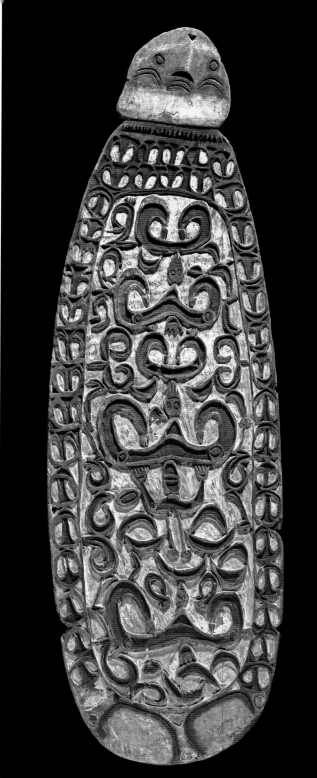

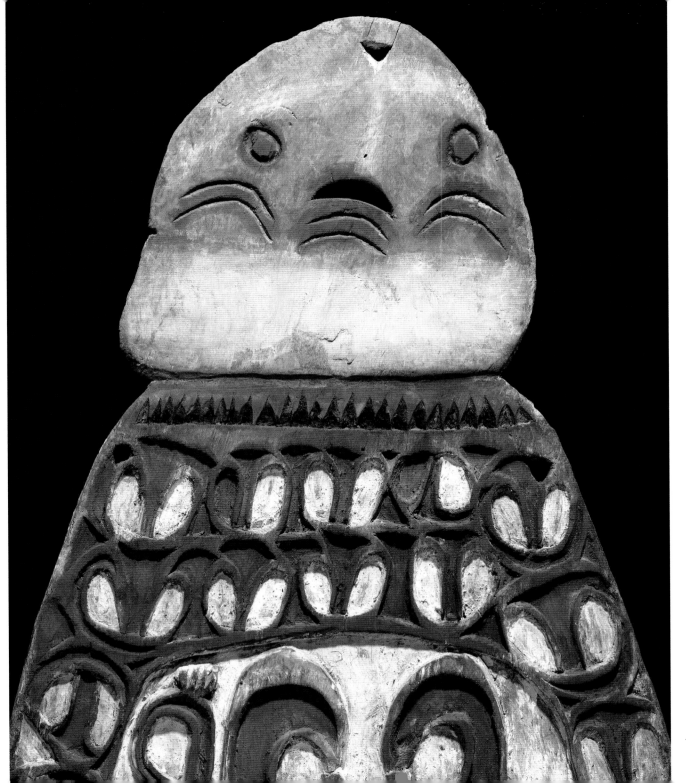

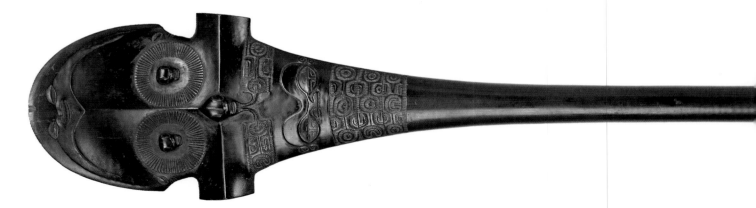

'U'u club.

Marquesas Islands, late 1700s to early 1800s.

Ironwood, human hair, coconut fibre.

L. 138.5 cm. W. 18 cm.

The head of this club – the *'u'u* that was the mark of a Marquesan warrior – presents a mesmerizing complex of faces on all sides, keeping watch in every direction. The *tiki*, or human figure, is a central focus of art of the Marquesas Islands. Here, larger faces are composed of small faces, combining and revealing eyes and faces in a series of visual puns. Some scholars have traced this layering and hiding of faces within geometric patterns to ancient Lapita pottery designs. The islands' first settlers would have brought in designs of Lapita origin, perhaps in tattoos from the western Pacific. The French artist Paul Gauguin, who lived his last years in the Marquesas, said: 'The basis of this art is the human body or face. The face, especially. You're astonished to find a face where you thought there was a strange geometrical figure. Always the same thing and yet never the same thing.'

Marquesan warriors (*toa*) carried their *'u'u* to indicate their status. When chiefs sent their *toa* into battle, they aimed to unnerve their adversaries with their visual impact. Wielding their imposing clubs and dressed in tall feather headdresses and ornaments, they also sported dramatic tattoos. A warrior is said to have acquired a new tattoo for every conquest, which when completed, covered his entire body.

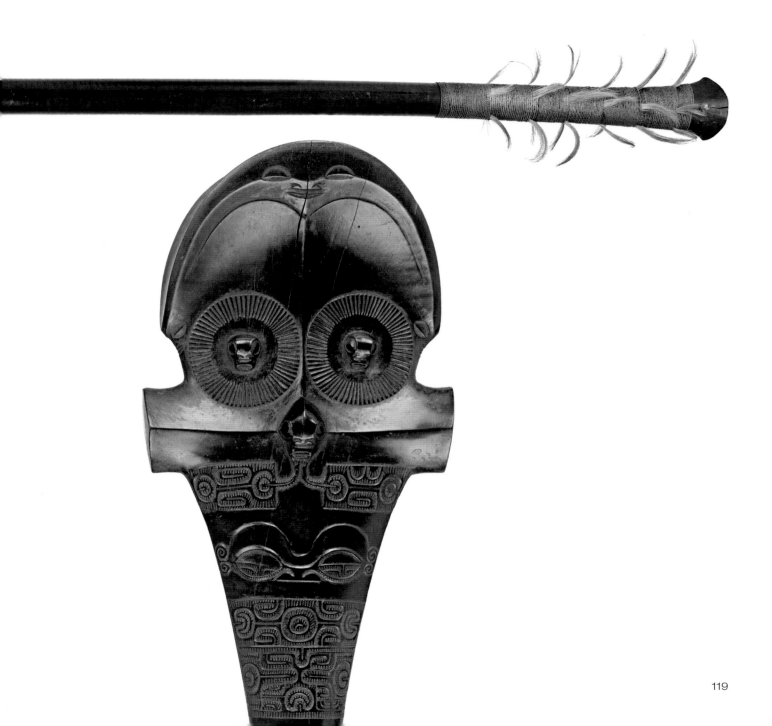

Warrior's gorget (*taumi*).

Tahiti, 1700s. Feathers, pearl shell, shark's teeth, dog fur, coconut fibre. H. 56 cm. W 57.5 cm.

Wearing this dazzling *taumi* on his chest, a Tahitian warrior created an imposing presence on the battlefield or on the fighting stage of a war canoe. The *taumi* was laboriously constructed from a base of densely woven coconut fibre cord, with a covering of lashed bundles of feathers, pierced shark's teeth and a fringe of dog fur. The use of such high-status, expensive materials added to the object's impressive display.

Shark's teeth and red and yellow feathers were associated with gods, and their inclusion may have helped in gaining the gods' attention and assistance.

Often worn as a pair, on chest and back, the *taumi* also provided some protection from blows and sling stones. Voyagers stopping at Tahiti in the late 1700s found islanders were willing to part with these important objects, and many were collected. The surgeon's mate on Captain George Vancouver's expedition of 1791–95 acquired this particular example in 1792.

Container with headhunting shell inlay.
Belau (Palau), probably 1800s.
Wood, shell. H. 23 cm. Di. 15.5 cm.

This container for holding valuables was made, like the ceremonial sword on page 80, as a prestige item for a Belauan chief (*Ibedul*). The vessel has a suspension cord to tie it safely to a house beam. It would have held glass money beads, an ancient form of currency, that is still carefully kept, exchanged and worn at important life events. The figures are headhunters, and each carries a weapon and a severed head. Headhunters are an appropriate image for an *Ibedul*, who relied upon violent attacks on his neighbours to maintain his territory and authority.

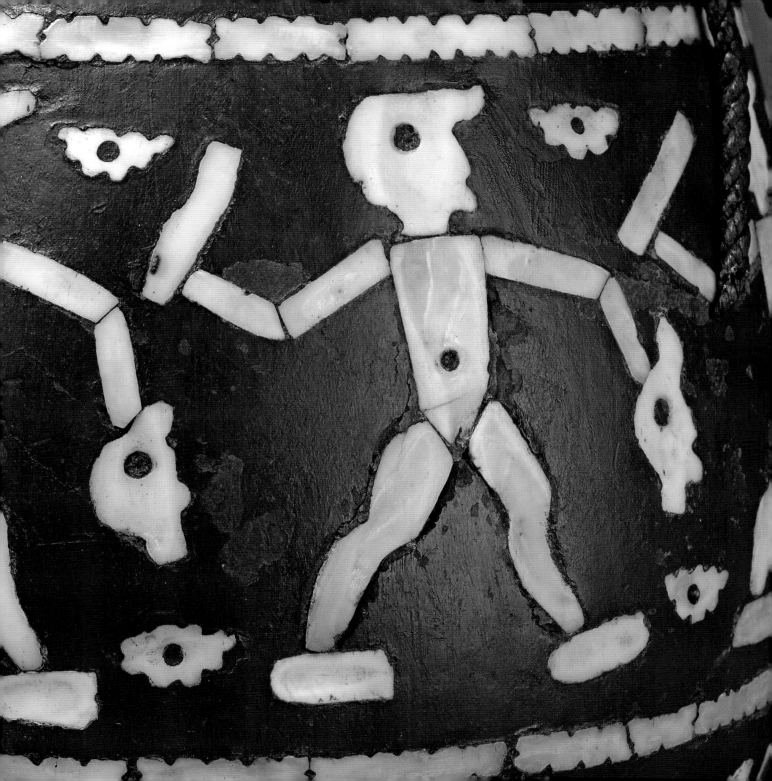

9

Art of Change

Europeans and islanders are joined as well as separated by histories.

Nicholas Thomas, 1995

Many artefacts in the British Museum's Oceania collection can be seen as 'cross-cultural'. They embody histories of meetings between Pacific and European cultures.

The arrival of Europeans into the Pacific was not the only phase of deep change to life in the islands. There had been earlier periods of widespread change. Early communities were established across the Pacific from 40,000 BC to the early centuries AD – the last of the great human migrations. Later long-distance travellers and traders arriving by sailing canoe bought their own cultural practices and perspectives to these communities, introducing new people, plants, animals, things and ideas. Other changes occurred whenever a society decided to install a new god to worship, or when the old ones grew ineffective.

European ships began arriving sporadically in the 1500s and more frequently from the mid-1700s. British, French and Spanish voyagers had a perhaps unprecedented depth and breadth of impact on the Pacific islands. These impacts ranged from diseases that decimated populations to the influence of missionaries and the domineering force of colonial governments. The operation of virtually every facet of life changed.

The things people in the Pacific made during the phases of change from the 1700s allow us views into how they experimented and adapted to new regimes, neighbours, new powers, technologies, fashions and ideas entering their region.

The different approaches to artworks, that European voyagers brought into the Pacific Islands opened up new avenues for experimentation. For instance, Tupaia, a high priest who joined the first Cook voyage in Tahiti, watched the voyage artists at work, borrowed paper and paints, and created representational images of the people and landscapes around him. The imagery he had known in Tahiti was symbolic, geometric or highly stylized imagery tattooed on skin, or incised on wood and stone, and designed to manage flows of power and connections to gods. Tupaia's drawings of the Māori and indigenous Australians he met during

Michel Tuffery, *Cookie in the Cook Islands*.
New Zealand, 2008. Paint on canvas. W. 76 cm. H. 51 cm.
British Museum. Reproduced by permission of the artist Michel
Tuffery M.N.Z.M, Aotearoa (New Zealand).
In his series 'First Contact', Michel Tuffery (an artist of Samoan, Tahitian
and Cook Islands descent) uses sculpture, paintings, drawings and
multimedia to invite his audience to reassess the story of contact between
the West and the Pacific. He opens up the story as a shared history, a
mutual process of creating change back and forth across the cultural
divide. Tuffery presents British explorer Captain James Cook as a man
deeply changed by his contacts with Polynesia: his identity is altered, as
marked by the hibiscus flowers, *hei-tiki* and his Polynesian features. These
changes are reflected in Tuffery's reference to him as 'Cookie', not only
as if he were a personal friend, but also because 'Cookie' is a throwaway
nickname for a Cook Islander.

the voyage are an arresting document of
the interest many Pacific Islanders had in
exploring new art forms and new horizons.

A broad slew of commodities flowed into
the Pacific in the 1800s, through whalers,
sandalwood traders, pearlers, sealers and
'Blackbirders' recruiting or kidnapping
workers for the plantations whites were setting
up. The value of things changed. Whaling
ships provided great quantities of whale
teeth and bones, whereas previously only the
occasional whale would wash up on shore. So
whale ivory – once rare and kept exclusively
for making ornaments for chiefs – became
available for more common use in Tonga,
Samoa and Fiji. On a much quicker path than
before, the meanings of things shifted.

The evidence of encounters and widespread
social and political change within objects
can be traced in museum collections. Pacific
Islanders have always responded to outsiders –
whether those outsiders are from other islands
or other oceans – with creativity, strength
and community cohesion. Fighting to defend
their shores, trading to make the most of the
good things on offer, working to deal with
settlers, joining in the newcomers' endeavours
– responses have always been dynamic. These
stories are the subject of our final chapter.

Replica Māori *patu* (hand club), cast with the crest of the British explorer and naturalist Sir Joseph Banks. England, 1772.
Brass. L. 36.5 cm. W. 10 cm. D. 3.8 cm.

This is a quintessentially cross-cultural object. It crosses the boundaries of Māori and British culture, creating a single object that belongs to both. It is in the of form a Māori stone hand club (*patu onewa*), yet in materials, construction and intent it is British. The coat of arms of one of Britain's Enlightenment celebrities of science, Sir Joseph Banks, is engraved on the blade, together with the year: 1772. Banks was on Captain James Cook's first voyage, and when in Aotearoa (New Zealand) was frustrated by the difficulties of trading with the Māori for artefacts. They seemed to value their own objects more highly than any the British could offer.

On returning to London, Banks commissioned Eleanor Gyles's foundry in Shoe Lane, Fleet Street, to cast in brass forty 'Patopatoes for New Zealand in imitation of their stone weapons', in preparation for returning to the Pacific. It seems he anticipated the most effective gifts and trade items would be objects the Māori already valued, made in a material that had proved appealing in most places they stopped. Banks did not end up returning to the Pacific. He gave the cast *patu* to his friend Charles Clerke, an officer on Cook's third voyage, who distributed them. A brass *patu* with Banks's crest was sighted in 1801 being carried by a Māori man on Aotearoa's North Cape; another was found among the grave valuables of a Native American on the northwest coast of the United States in the early 1900s.

While the brass *patu* were not intended for warfare, they did share with Māori hand clubs, (carved of basalt and *pounamu* (nephrite jade)) the role of a high-calibre item of exchange. These intriguing gifts from England, fusing Māori design with British materials and identity, seem to have been treasured by those who received them.

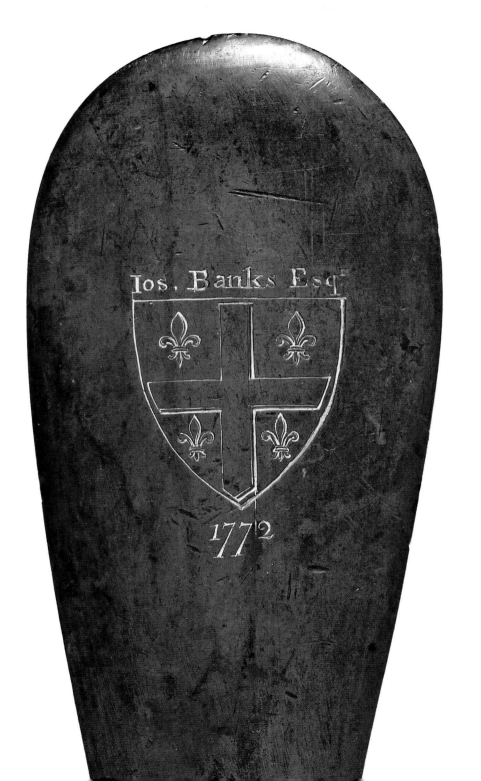

Decorated barkcloth (*hiapo*).
Niue, 1900s. Barkcloth. L. 228 cm. W. 186 cm.

'These works of art seem to rush towards the twenty-first century like a lamina of forest.'

(John Pule, 2005)

The ordered energy of the patterning on this sheet of barkcloth has been given an unexpected jolt by the figurative representation of a colonial woman. As Niuean artist John Pule and Pacific anthropologist Nicholas Thomas have suggested, the artist's inclusion of an out-of-step element – a shift of representational styles – in an otherwise ordered composition could have been a way to unsettle it, to add to the dynamism and energy of the work. Yet this has long been one of the qualities of an effective *hiapo*. The imagery of these paintings is also like an historic document – it allows glimpses into the everyday life of the island's artists and their visitors and settlers.

Tapa (called *hiapo* in Niue) has a long history of significance across the Pacific. Lengths of *tapa* have been used to wrap people and things, to contain and protect their sacredness. It is still used in many islands for domestic coverings and high-status gifts.

Poncho (*tiputa*) with scissor-cut designs. Tahiti, late 1700s. Barkcloth (*tapa/ 'ahu*). L. 225 cm. W. 126 cm.

This Tahitian *tiputa* (poncho) is made of the soft, finely beaten inner layer of the bark of a mulberry tree. Worn by placing the central slit over the head, the bold triangular designs would drape over one shoulder. Women started experimenting with patterning their *tapa* (barkcloth) from the 1760s, after seeing the printed cloth brought by British, French and Spanish ships. Tahitian *tapa* had more usually been bleached white, coloured with plant dyes or subtly marked with the end of a dye-dipped bamboo rod.

The fern-leaf impressions on this *tiputa* were probably inspired by European sprigged cloth. Another innovation, which you can see here, was to use scissors to cut intricate silhouettes from darker-dyed *tapa*. Women bartered keenly with the sailors to acquire scissors and ships' captains were soon carrying scissors by the hundreds to trade for food and other goods. The iron tools, clothes, guns and other items they brought to the islands were taken up with relish and brought deep changes in their wake.

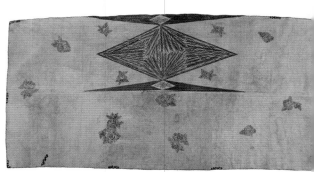

Bonnet of turtle shell. Samoa, mid-1800s. Turtle shell, vegetable fibre thread, imported cotton cloth. H. 31cm. W. 36.7 cm. D. 30 cm.
The Samoan-based missionary George Turner, writing in 1861, reported on a fashion among Samoan women for wearing European straw bonnets and shawls. When bonnets were in short supply, he said, some women 'showed great ingenuity in manufacturing a novel and very durable article from tortoise-shell'. Samoan women saw an increasing range of exotic European clothing from the 1830s as missionaries, then settlers and travellers, appeared on the islands. Traders brought in quantities of patterned cotton cloth, also popular with island women. Some sprigged cloth has been used to cover the rough edges of this bonnet. Each plate has been heated, shaped and pierced along the edges, then sewn with vegetable fibre thread.

This is probably the only turtle-shell bonnet in a museum collection. The route by which it reached England is not known. It was given to Queen Victoria before 1841, then donated to the British Museum. In 1850 it was documented as being on display in the Ethnography Gallery.

Model house.

Samoa, *c.*1886 or 1887.

Palm leaf, wood, barkcloth (*siapo*), wool.

H. 64 cm. W. 80 cm. D. 70 cm.

Samoan craftspeople began to make models for tourists – small houses, canoes and other components of traditional life – just as these forms were beginning to be replaced or changed by imported things. This is a large, heavy model designed not for tourists, but for the thronging crowds at London's Colonial and Indian Exhibition of 1886. Chief Malietoa Laupepa, 'King of Samoa', clearly wanted the educational impact of this model and a number of other

Samoan artefacts to continue for the British public: after the exhibition, he donated the collection to the British Museum.

The model demonstrates the typical solid-pole construction, elegant lashing and dense sugarcane or palm-leaf thatch of a traditional Samoan *fale* (shown right). It also features large mats for the walls. The walls on an actual *fale* are usually formed of a hanging set of long rectangular mats, which can be raised and lowered to control the flow of cooling breezes.

The *fale* form is still built with wood, palm leaves and barkcloth, but corrugated iron and concrete are now the more common materials.

Engraved bamboo containers (*kare u ta*).
New Caledonia, second half of the 1800s. Bamboo.
TOP (TWO VIEWS): L. 144 cm. Di. 6 cm.
BOTTOM: L. 123.6 cm. Di. 3 cm.

These lengths of bamboo, finely engraved, are enigmatic objects and were presented to male elders in New Caledonia on reaching a particular high level of authority. They were also containers, carrying a selection of magical plants that protected the owner. Oral traditions state that carrying one of these impressive objects would improve a man's chances while courting.

Master engravers, apparently a hereditary group, fasted before starting the work in which they were guided by ancestor spirits. Some of the captivating imagery and geometric patterns appear to have been illustrations and aides-memoires for recounting

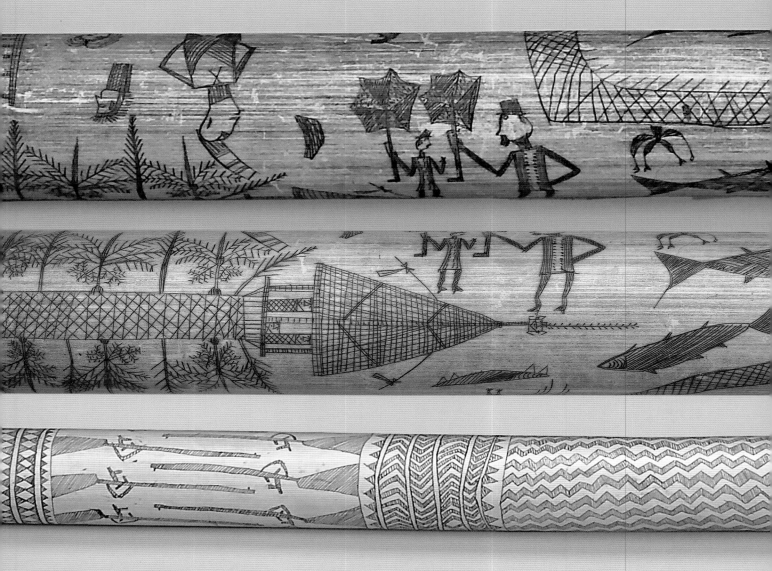

histories of the ancestors. This imagery is not only about ancestors, however. *Kare u ta* in museum collections around the world, all of which were collected between 1850 and 1920, are vivid expressions of the changes under way on the islands. French soldiers parade about, muskets are lined up, ships sail across the surface, and dandies with fine jackets and umbrellas

strike poses. In between these sometimes ironic recordings of new features of colonial New Caledonian life, indigenous Kanak traditions continue: fish are netted, Kanak houses stand proudly, and local animals are as much in evidence as the imported horses. Life goes on.

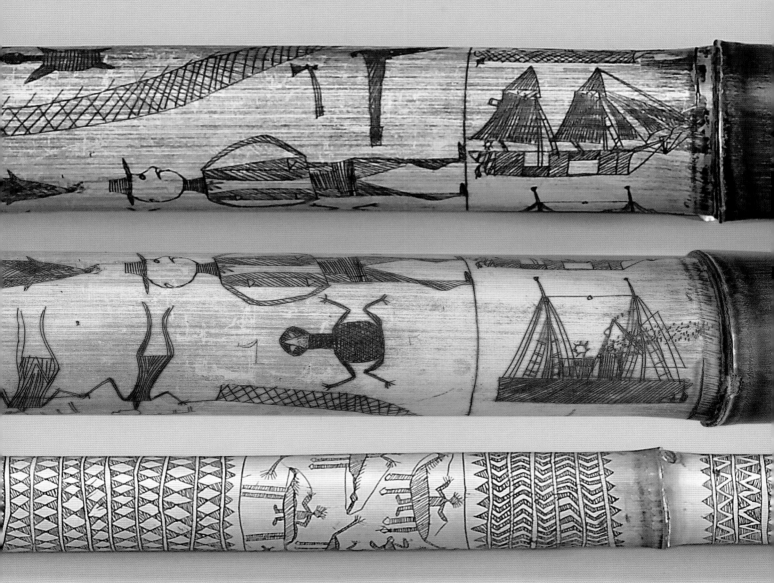

Dala made of a Wedgwood plate.
Roviana, Solomon Islands, before 1900.
Ceramic, turtle shell. Di. 13.5 cm. D. 1.5 cm

A *dala* is a status object featuring a fine, exacting design. Using a strip of bamboo inserted into drilled holes to saw out small sections, the design was carved out of a circle of turtle shell. The delicate fretwork circle was usually attached to a disk of white clamshell. The maker of this *dala*, however, used a material that became available in the Solomon Islands from the mid-1800s: British-made porcelain. The artist was particularly interested in the plate's white underside: with its ready-made rim and flat profile, it would have been much easier to work than clamshell. The plate acquired a new role as a dignified valuable to be worn on the forehead or chest.

The aesthetic pathway seen here from China to Britain to the Solomon Islands is typical of the kinds of entanglements made through artworks, linking the Pacific and its artists to the rest of the world. Pacific Islander artists have continued to innovate and reflect the changing world in their works, in ways that have created new meanings and provided new sources of inspiration for their audiences within and beyond the Pacific.

10
Further Information

The Pacific: Introductory reading

I. C. Campbell, *A History of the Pacific Islands*, Canterbury University Press, 1992.

B. V. Lal and K. Fortune (eds), *The Pacific Islands: An Encyclopedia*, University of Hawai'i Press, 2000.

K. R. Howe, R. C. Kiste, B. V. Lal, *Tides of History: The Pacific Islands in the Twentieth Century*, University of Hawai'i Press, 1994.

Pacific Art: Introductory reading

L. Bolton, N. Thomas, L. Bonshek, J. Adams (eds), *Melanesia: Art and Encounter*, British Museum Press, 2011.

A. D'Alleva, *Arts of the Pacific*, Weidenfeld & Nicolson, 1998.

J. Feldman and D.H. Rubinstein, *The Art of Micronesia*. The University of Hawai'i Art Gallery, 1986.

S. Hooper, *Pacific Encounters: Art and Divinity in Polynesia 1760–1860*, British Museum Press/ Sainsbury Centre for the Visual Arts, 2006.

A. L. Kaeppler, C. Kaufmann, D. Newton, *Oceanic Art*, Harry N. Abrams, 1997.

E. Kjellgren, *Oceania: Art of the Pacific Islands in the Metropolitan Museum of Art*, Metropolitan Museum of Art and Yale University Press, 2007.

S. Küchler and G. Were, *Pacific Pattern*, Thames & Hudson, 2005.

S. Mead and B. Kernot (eds), *Art and Artists of Oceania*, Dunmore Press, 1983.

R. Neich and M. Pendergrast, *Pacific Tapa*, Bateman/Auckland Museum, 1999.

N. Thomas, *Oceanic Art*, Thames and Hudson, 1995.

Art of the Moment

S. Baker, *Make Your Own Bilum*, Boolarong Publications, 1986.

J. Hammond, *T faifai and Quilts of Polynesia*, University of Hawai'i Press, 1986.

A. and L. Hanson (eds), *Art and Identity in Oceania*, University of Hawai'i Press, 1990.

S. Mallon and P. F. Pereira, *Speaking in Colour: Conversations with Artists of Pacific Island Heritage*, Te Papa Press, 1997.

M. O'Hanlon, *Paradise: Portraying the New Guinea Highlands*, Crawford House and British Museum Press, 1993.

P. Rossi (ed.), *Hailans to Ailans: Contemporary Art of Papua New Guinea*, Alcheringa Gallery and Rebecca Hossack Gallery, Victoria, B.C., Canada and London, 2009.

D. R. Smith, 'The Palauan Storyboards: From Traditional Architecture to Airport Art', *Expedition*, 9/1 (1975): 2-17.

Sea of Islands

H. G. Beasley, *Pacific Island Records: Fish Hooks*, Seeley, Service & Co., 1928.

P. Bellwood, *Polynesians: Prehistory of an Island People*, Thames and Hudson, 1987.

P. D'Arcy, *People of the Sea: Environment, Identity and History in Oceania*, University of Hawai'i Press, 2006.

W. A. Davenport, 'Marshall Islands Cartography', *Expedition*, 6/ 4 (1964): 10-13.

A. C. Haddon and J. Hornell, *Canoes of Oceania*, Bishop Museum Press, 1936, new edn 1975.

K. R. Howe, *Vaka Moana: Voyages of the Ancestors; The Discovery and Settlement of the Pacific*, Bateman/Auckland Museum, 2007.

J. Malnic, *Kula: Myth and Magic in the Trobriand Islands*, Cowrie Books, 1998.

M. Montvel-Cohen, *Continuity and Change in the Material Culture of Micronesia*, Isla Center for the Arts (University of Guam), 1987.

D. Moore, *Arts and Crafts of Torres Strait*, Shire publications, 1989.

Gods and Spirits

F. Clunie, *Yalo i Viti: Shades of Viti: A Fiji Museum Catalogue*, Fiji Museum, Suva, 1986.

C. Colchester (ed.), *Clothing the Pacific*, Berg, 2003.

J. H. Cox and W. H. Davenport, *Hawaiian Sculpture*, University of Hawai'i Press, 1988.

A. C. Haddon, 'The Agiba Cult of the Kerewa Culture', *Man*, 99, December 1918.

Te Rangi Hiroa (P. Buck), *Arts and Crafts of the Cook Islands*, Bishop Museum Bulletin 179, 1944, new edn 1971.

B. Maysmor, *Te Manu Tukutuku: The Maori Kite*, Steele Roberts, 2001.

K. St. Cartmail, *Art of Tonga/Ko e Ngaahi'aati'o Tonga*, University of Hawai'i Press, 1997.

Living with Ancestors

B. A. L. Cranstone and H. J. Gowers, 'The Tahitian Mourner's Dress: A Discovery and a Description', *The British Museum Quarterly*, 32/3-4, Spring 1968: 138-144.

M. Gunn and P. Peltier (eds), *New Ireland: Art*

of the South Pacific, musée du quai Branly, 2006.

M. Hennen Huber, *Time and Tide: The Changing Art of the Asmat of New Guinea*, Minneapolis Institute of the Arts, 2009.

L.A. Klein and E.W. Miller, *People of the River/ People of the Tree: Change and Continuity in Sepik and Asmat Art*, Minnesota Museum of Art, 1989.

E. Kjellgren, *Splendid Isolation: Art of Easter Island*, Metropolitan Museum of Art and Yale University Press, 2002.

D. Starzecka, 'The Spirit Figures Leave Home' [On Abelam], *British Museum Society Bulletin*, 37, 1981: 8-11.

D. Starzecka (ed.), *Maori Art and Culture*, British Museum Press, 1996.

J. Van Tilburg, *Easter Island: Archaeology, Ecology and Culture*, Smithsonian Institution Press, 1995.

J. Van Tilburg, *Hoa Hakananai'a*, British Museum Press, 2004.

T. P. van Baaren, *Korwars and Korwar Style: Art and Ancestor Worship in North-West New Guinea*, Mouton, 1968.

Art of Power

J. Bonnemaison, et al., *Arts of Vanuatu*, Crawford House, 1996.

E. Bonshek, 'A personal narrative of particular things: Tevau (feather money) from Santa Cruz, Solomon Islands', *Australian Journal of Anthropology*, 20 (1), April 2009: 74-92.

W. Davenport, 'Red-feather money', *Scientific American*, 206 (1962).

A. Edmundson and C. Boylan, *Adorned: Traditional Jewellery and Body Ornament from Australia and the Pacific*, Macleay Museum, University of Sydney, 1999.

E. Kasarherou, *Le Masque Kanak*, Editions Paranthéses/ADCK, 1993.

K. Nero and N. Thomas (eds), *An Account of the Pelew Islands* (1788), Leicester University Press, 2002.

D. Rubinstein and S. Limol, 'Reviving the Sacred Machi: A Sacred Weaving from Fais Island, Micronesia', in R. Hamilton and B. Lynne Milgram (eds), *Material Choices: Refashioning Bast and Leaf Fibres in Asia and the Pacific*, Fowler Museum at UCLA, 2007.

D. C. Starzecka, *Hawaii: People and Culture*, British Museum Press, 1975.

V. Valeri, *Kingship and Sacrifice: Ritual and Society in Ancient Hawai'i*, University of Chicago Press, 1985.

Art of Dance

K. Alexeyeff, *Dancing from the Heart: Movement, Gender, and Cook Islands Globalization*, University of Hawai'i Press, 2009.

P. Bennets and T. Wheeler, *Time and Tide: the Islands of Tuvalu*, Lonely Planet, 2001.

I. Heermann, *Form, Colour, Inspiration: Oceanic Art from New Britain*, Arnoldsche, 2001.

R. Moyle, *Polynesian Sound-Producing Instruments*, Shire Publications, 1990.

Art of War

H. Beran, et al. *Shields of Melanesia*, Crawford House Publishing, 2005.

M. T. Etpison, *Palau: Cultural History*, Tkel Corp, Koror, 2004.

R. Kekumuikawaokeda Paglinawan et al., *Lua: The Art of the Hawaiian Warrior*, Bishop Museum Press, 2006.

E. Kjellgren and C. Ivory, *Adorning the World: Art of the Marquesas Islands*, Metropolitan Museum of Art and Yale University Press, 2005.

D. Oliver, *Ancient Tahitian Society*, Australian National University, 1975.

D. A. M. Smidt (ed.), *Asmat Art: Woodcarvings of Southwest New Guinea*, George Braziller, 1993.

A. Talu et al., *Kiribati: Aspects of History*, University of the South Pacific/Ministry of Education, Training and Culture, Kiribati, 1979.

Art of Change

J. Coote, *Curiosities from the Endeavour: A Forgotten Collection*, Captain Cook Memorial Museum, 2004.

S. Koojiman, *Tapa in Polynesia*, Bishop Museum Press, 1972.

S. Mallon, *Samoan Art and Artists: O Measina a Samoa*, Craig Potton Publishing, 2002.

J. Pule and N. Thomas, *Hiapo: Past and Present in Niuean Barkcloth*, University of Otago Press, 2005.

N. Thomas, *In Oceania: Visions, Artifacts, Histories*, Duke University Press, 1997.

T. Weber and J. Watson (eds), *Cook's Pacific Encounters*, National Museum of Australia, Canberra, 2006.

Sources of quotations

Preface
Rosanna Raymond, quoted by D. Brown in R. Raymond and A. Salmond (eds), *Pasifika Styles: Artists Inside the Museum*, University of Cambridge Museum of Archaeology and Anthropology and Otago University Press, 2008, p. 28.

Chapter 1
Page 8 (Epigraph) Michael Mel, in D. Lepsoe, 'An Interview with Michael Mel', in P. Rossi (ed.), 2009, p. 64.

Page 9 (On indirectness) A. Kaeppler in A. Kaeppler at al. 1997, p. 26.

Chapter 2
Page 16 (Epigraph) Michel Tuffery, in S. Mallon and P. F. Pereira 1997, p. 121.

Page 17 (On tradition) A. D'Alleva, 1998, p. 156.

Page 18 (Regenvanu painting) R. Regenvanu, artist's statement, 2006. http://www.vanuatuculture.org/site-bm2/contemporary/20060522_ralphbm.shtml

Chapter 3
Page 32 (On sea of islands) Epeli Hau'ofa, 'Our Sea of Islands', in *We Are the Ocean: Selected Works*, University of Hawai'i Press, 2008, pp. 27-40.

Page 33 (On canoes and men) M. Montvel-Cohen 1987, p. 9

Page 36 (Canoe) R. Brodhurst-Hill, Chelsworth, Suffolk, letter to the British Museum Ethnography Department, 29 April 1965. Centre for Anthropology, British Museum.

Page 42 (Kula splashboard) John Kasaipwalova, chief of Kwenama clan, Kiriwina Island, 1982, quoted by Jutta Malnic, in J. Malnic 1998, p. 100.

Chapter 4
Page 53 (Marupai) Quote from F. E. Williams, Drama of Orokolo, Clarendon Press, 1940, p. 105, in M. J Young and J. Clark, *An Anthropologist in Papua: The Photography of F.E. Williams 1922-1939*, University of Hawai'i Press, 2001, p. 189.

Page 54 (Yaqona dish) Quote from Captain Erskine, reporting on the dish seen by Captain Worth of HMS Calypso in 1848, quoted in F. Clunie 1986, p. 115.

Page 58 (Staff god) John Williams, *A Narrative of Missionary Enterprises in the South Sea Islands*, J. Snow, 1837, p. 116.

Chapter 5
Page 77 (Korwar) Missionary J. L. van Hasselt, 1876, quoted in E. Kjellgren 2007, p. 38.

Chapter 7
Page 98 (Epigraph) Quoted in K. Alexeyeff 2009, p. 5.

Page 98 (On festivals) A. Kaeppler, 'Festivals of Pacific Arts: Venues for Rituals of Identity', *Pacific Arts, Journal of the Pacific Arts Association*, 25, Dec 2002, 5-19: 17.

Chapter 8
Page 112 (chant), R. Kekumuikawaokeda Paglinawan et al. 2006.

Page 113 (On aesthetics of intimidation) N. Thomas 1995, p.92

Page 118 (U'u) P. Gauguin, from D. Guérin (ed.), The Writings of a Savage, Viking Press, 1978, p. 280, quoted in E. Kjellgren and C. Ivory 2005, p.31.

Chapter 9
Page 124 (On entangled histories) N. Thomas 1995, p.12.

Page 128 (Hiapo) John Pule, in J. Pule and N. Thomas 2005, p.19.

British Museum Press publications

L. Bolton, N. Thomas, L. Bonshek, J. Adams (eds), *Melanesia: Art and Encounter*, 2011.
B. Burt, *Body Ornaments of Malaita*, Solomon Islands, 2009.
B. Burt and M. Kwaioloa (eds), *A Solomon Islands Chronicle*, as told by Samuel Alasa'a, 2001.
B. Burt, *Solomon Islanders: The Kwara'ae*, 1981.

S. Hooper, *Pacific Encounters: Art and Divinity in Polynesia 1760-1860*, 2006.
R. Jewell and J. Lloyd, *Pacific Design*, 1998.
S. Küchler and A. Eimke, *Tivaivai: The Social Fabric of the Cook Islands*, 2009.
M. Kwaioloa and B. Burt, *Living Tradition: a Changing Life in Solomon Islands*, 1997.

J. Van Tilburg, *Hoa Hakananai'a*, 2004.
J. Van Tilburg, *Remote Possibilities: Hoa Hakananai'a and HMS Topaze on Rapa Nui*, British Museum Research Publication no. 158, 2005.

British Museum collections and website

Many of the books listed above can be consulted in the Paul Hamlyn Library, a free-entry public reference library at the British Museum. More information on Oceanic cultures and the Museum's collection can be found at the Centre for Anthropology at the British Museum.

The registration record and images of the each of the objects in this book are available digitally on the Collections Database: www.britishmuseum.org/research/search_the_collection_database.aspx

The 'Explore' tab provides options for online tours of the Pacific collection, including the 'Power and Taboo' and 'Gods and People' tours. Highlights of the collection can also be searched on this tab.

Other Pacific collections

Significant collections:

UK and Ireland
Belfast: Ulster Museum. www.nmni.com/um
Cambridge: Museum of Archaeology and Anthropology. www.maa.cam.ac.uk
Dublin: National Museum of Ireland. www.museum.ie
Edinburgh: National Museums Scotland. www.nms.ac.uk
Exeter: Royal Albert Memorial Museum. www.rammuseum.org.uk
Glasgow: Kelvingrove Art Gallery and Museum. www.glasgowmuseums.com
London: Horniman Museum. www.horniman.ac.uk
Liverpool: World Museum Liverpool. www.liverpoolmuseums.org.uk/wml/
Manchester: Manchester Museum. www.museum.manchester.ac.uk/
Oxford: Pitt Rivers Museum. www.prm.ox.ac.uk

Europe
Amsterdam: Tropenmuseum. www.tropenmuseum.nl.
Basel: Museum der Kulturen. www.mkb.ch
Berlin: Ethnologisches Museum. www.smb.spk-berlin.de/mv
Bremen: Übersee-Museum. www.uebersee-museum.de
Brussels: Musées Royaux d'Art et d'Histoire. www.kmkg-mrah.be
Budapest: Néprajzi Múzeum. www.neprajz.hu
Cologne: Rautenstrauch-Joest-Museum. www.museenkoeln.de/rautenstrauch-joest-museum
Copenhagen National Museum of Denmark. www.nationalmuseet.dk/sw20379.asp
Dresden: Museum für Volkerkunde. www.voelkerkunde-dresden.de
Florence: Museo di Antropogia e Etnologia. www.msn.unifi.it/CMpro-l-s-7.html
Frankfurt: Museum der Weltkulturen. www.mwk-frankfurt.de
Geneva: Musée D'Ethnographie De Genèva. www.ville-ge.ch/meg
Geneva: Musées Barbier-Mueller. www.barbier-mueller.ch
Göttingen: Institut für Ethnologie. www.uni-goettingen.de/en/38813.html
Hamburg: Museum für Volkerkunde. www.voelkerkundemuseum.com/
Leiden: National Museum of Ethnology. www.rmv.nl
Leipzig: Museum für Volkerkunde. www.mvl-grassimuseum.de/
Munich: Museum für Völkerkunde. www.voelkerkundemuseum.com
Paris: Musée du Quai Branly. www.quaibranly.fr
Rome: Vatican Museums. mv.vatican.va/3_EN/pages/MET/MET_Main.html

Rotterdam: Wereldmuseum. www.wereldmuseum.com
Stockholm:
St Petersburg: Museum of Anthropology and Ethnology. www.kunstkamera.ru/en
Stuttgart: Linden-Museum. www.lindenmuseum.de
Vienna: Museum für Volkerkunde. www.ethno-museum.ac.at

North America
Bloomington: IU Art Museum. www.indiana.edu/~iuam
Chicago: Field Museum. www.fieldmuseum.org
Cambridge: Peabody Museum of Archaeology and Ethnology, Harvard University. www.peabody.harvard.edu
Los Angeles: Fowler Museum at UCLA. www.fowler.ucla.edu
New Haven: Yale Peabody Museum. www.peabody.yale.edu
New York: The Metropolitan Museum of Art. www.metmuseum.org
New York: American Museum of Natural History. www.amnh.org/
Philadelphia: The University of Pennsylvania Museum of Archaeology and Anthropology. www.penn.museum
Saint Louis: Saint Louis Art Museum, www.slam.org
Salem: Peabody Essex Museum. www.pem.org
Vancouver: Museum of Anthropology at the University of British Columbia. www.moa.ubc.ca
Washington: Smithsonian Institution. www.si.edu

Asia
Osaka: National Museum of Ethnology. www.minpaku.ac.jp

Oceania
For a more complete list of Pacific museums: www.collectionsaustralia.net/pima

Adelaide, Australia: South Australian Museum www.samuseum.sa.gov.au
Apia, Samoa: Museum of Samoa. via www.mesc.gov.ws
Auckland, New Zealand: Auckland Museum. www.aucklandmuseum.com
Brisbane: Queensland Museum: www.qm.qld.gov.au
Canterbury, New Zealand. www.canterburymuseum.com
Dunedin, New Zealand: www.otagomuseum.govt.nz
Guam: Guam Museum. www.guammuseum.com
Hobart: The Tasmanian Museum and Art Gallery. www.tmag.tas.gov.au
Honolulu, Hawai'i: Bernice Pauahi Bishop Museum. www.bishopmuseum.org
Honolulu, Hawai'i: Honolulu Academy of Arts. www.honoluluacademy.org

Koror, Belau: Belau National Museum. www.belau-nationalmuseum.org
Melbourne, Australia: Museum Victoria. museumvictoria.com.au
Nouméa, New Caledonia: Centre Culturel Tjibaou. www.adck.nc
Nouméa: Musée de Nouvelle-Calédonie. www.museenouvellecaledonie.nc
Sydney, Australia: Australian Museum. www.australianmuseum.net.au
Suva, Fiji: Fiji Museum. www.fijimuseum.org.fj
Otago, New Zealand: Otago Museum. www.otagomuseum.govt.nz
Port Moresby, PNG: National Museum and Art Gallery, Boroko
POB 5560 Port Moresby, Papua New Guinea. Tel: +675 252 405
Port Vila, Vanuatu: Vanuatu Cultural Centre. www.vanuatuculture.org
Punauuia, Tahiti: Musée de Tahiti et des îles. www.museetahiti.pf
Rarotonga, Cook Islands: Cook Islands Library and Museum Society: http://cookislandslibrary-andmuseum.blogspot.com/ and Cook Islands Museum. www.mocd.gov.ck
Wellington, New Zealand: Te Papa Tongarewa. www.tepapa.govt.nz

Glossary

ali'i Hawaiian chief.

Aotearoa Māori name for New Zealand.

Atua gods/divine ancestors, Polynesia.

bai Belauan men's house.

bilum net bag, Papua New Guinea.

dala shell valuable of Malaita, Solomon Islands, worn on the chest or forehead.

fale house, Samoa.

korombo Abelam mens' house.

malagan system of mortuary ceremonies, and their masks, New Ireland.

mana sacred power in Polynesian and some Melanesian cultures.

Melanesia cultural-geographic region, west Pacific. Includes the major island groups of Papua New Guinea and associated islands, the Solomon Islands, Vanuatu, and New Caledonia.

Micronesia cultural-geographic region, northwest Pacific. The region includes the Caroline Islands, which encompass the Federated States of Micronesia (including the states of Pohnpei, Chuuk, Yap and Kosrae), Belau (Palau) and Nauru, the Mariana Islands (including Guam and the Northern Mariana Islands), as well as the Marshall Islands and Kiribati.

moai large stone ancestor figure, Rapanui.

moko Māori facial tattoo.

nasara ceremonial site, Vanuatu.

Ni-Vanuatu indigenous people of Vanuatu

heiau Hawaiian ceremonial site.

hiapo Nieuan barkcloth.

Ibedul Belauan chief.

iwi Māori tribal group.

jipae ceremony for dealing with spirits, also the full-body masks created for this ceremony.

Kanak indigenous people of New Caledonia.

kastom Ni-Vanuatu word for custom, traditional culture.

kava narcotic drink made of kava root, drunk ritually or socially.

kula system of cyclic, symbolic trade, Trobriand Islands.

Lapita distinctively-marked pottery ware and archaeological marker of the ancestral culture of Polynesian as well as many Micronesian and Melanesian peoples.

Maohi 'people of the land', Society Islands.

Māori 'people of the land', Aotearoa/New Zealand.

marae sacred 'temple' site, French Polynesia.

olōna (*Touchardia latifolia*) Hawaiian plant, used to make a fine fibre.

pā Māori fortified settlement.

Pākehā whites in Aotearoa/New Zealand.

Polynesia cultural-geographic region, central and eastern Pacific. The points of the Polynesian triangle are marked by Hawai'i, Rapa Nui and Aotearoa/New Zealand. Within this lie groups such as the Austral Islands, Society Islands, the Marquesas, the Cook Islands, Tonga and Samoa.

pounamu nephrite jade, greenstone.

PNG Papua New Guinea.

rakau whakapapa genealogy staff, Māori.

Siapo Samoan barkcloth.

Tangaroa Māori creator god.

taonga sacred treasure, Māori.

tapu sacred, restricted (taboo).

tiki anthropomorphic figure, parts of Polynesia.

whakapapa genealogy, Māori.

wharenui Māori meeting house.

yaqona (or kava) narcotic drink, Fiji.

British Museum registration numbers

Unless otherwise stated, all images in this book are copyright of The Trustees of the British Museum.

Prelims
Oc1906,1013.5 (skull rack)
Oc1952,03.47 (shield)
Oc2005,05.24.l (textile)

Chapter 1 What is Pacific Art?
Oc1980,11.273 (bowl)
Oc1990,09.4 (shield), purchased with the support of BM Friends, 1990.
Oc1987,04.7 (painting)
Oc1915,-.61 (pendant), purchased through Christy Fund, 1915.
Oc1944,02.943 (mask), gift of Irene M. Beasley, 1944.

Chapter 2 Art of the Moment
Oc2006,02.1 (painting), gift of Melanesian Arts Project, 2006.
Oc2006,06.1 (print), gift of Queensland Government, 2006.
2008,2004.28 (bilum)
Oc2004,02.1 (quilt)
Oc1994,04.117 (sculpture)
2008,2004.34 (plaque)
Oc1987,03.1 (storyboard)

Chapter 3 Sea of Islands
Oc,Haw.62 and Oc1987,Q.11 (hooks)
Oc1927,1112.1 (prow)
Oc1927,1022.1 (canoe), gift of Lady Lever Art Gallery, 1927.
Oc1904,0621.14 (figure)
Oc1944,02.931 (chart), gift of Irene M. Beasley, 1944.
Oc1999,Q.140 (sail)
Oc1926,-.95 (mask), purchased through Christy Fund, 1926.
Oc,M.66 (splashboard), purchased through Christy Fund, 1922.

Chapter 4 Gods and Spirits
Oc,Tah.133 (goddess figure)
Oc1839,0426.8 (god figure), gift of

W. Howard, 1839.
Oc,LMS.19 (god figure)
Oc1906,1013.5 (skull rack), gift of Prof C. G. Seligman, 1906.
Oc1951,07.69 (marupai)
Oc1842,1210.127 (dish), gift of Sir E. Belcher, 1842.
Oc1843,0710.11 (kite), gift of Mr. Read, 1843.
Oc1978,Q.845 (staff god)
Oc2003,02.4 (dress), gift of Dr Suzanne Küchler, 2003.

Chapter 5 Living with Ancestors
Oc1908,0423.1 (pestle)
Oc1906,0416.1 (hei-tiki)
Oc1854,1229.22 (staff), gift of Sir George Grey, 1854.
Oc1869,1005.1 (Moai), gift of Queen Victoria, 1869.
Oc,+.2595 (Moai kavakava), gift of Sir A. W. Franks, 1885.
Oc,Tah.78 (costume)
Oc1927,1119.2 (lintel), gift of Mrs M Reid, 1927.
Oc1975,01.1 (body mask)
Oc1980,11.110 (female figure)
Oc1865,0503.3 (korwar), gift of C. J. Jessop, 1865.
Oc1884,0728.20.a (malagan), gift of Duke Francis Russell, 1884.

Chapter 6 Art of Power
Oc1875,1002.3 (brotech). Bequeathed by Rev W. Wills & Miss Salter, 1875.
Oc,Haw.133 (cloak)
Oc,Haw.47 (bowl)
Oc.1969 (fan), gift of Henry Christy, 1866.
Oc1851,0103.160 (spatula), gift of Capt Owen Stanley, 1851.
Oc1944,02.1086 to 1090 (grade textiles), gift of Irene M. Beasley, 1851.
Oc1928,0412.18 (loin cloth)
Oc1976,11.236 (feather money).
Oc1954,06.260 (mask), gift of Wellcome Institute, 1954.

Chapter 7 Art of Dance
Oc,Haw.157 (bracelet)
Oc2004,02.10, 11 & 12 (costume)
Oc.6961 (drum), gift of A. J. B. Beresford Hope, 1870.
Oc1997,04.1 (headdress), purchased through Jean Sibley Donation, 1997.
Oc1978,Q.660 (headdress)
Oc1900,-.65 (dance 'club'), gift of Rear-Adm. G. Hand, 1900.
Oc1993,06.28 (skirt), gift of Tony Atkinson, 1993.

Chapter 8 Art of War
Oc1931,0714.33 (breastplate), gift of Lady Elsie E. Allardyce, 1931.
Oc,LMS.10 (weapon)
Oc1887,0201.54 (helmet), gift of Harry J Veitch, 1887;
Oc.1973 (cuirass), gift of Royal Botanic Gardens, Kew, 1866.
Oc1969,13.78 (shield)
Oc1920,0317.1 (club), gift of Thomas Boynton, 1920.
Oc,Van.344 (gorget), gift of Sir Augustus Wollaston Franks, 1891.
Oc1972,Q.95.a and b (container)

Chapter 9 Art of Change
2009,2026.1 (painting), purchased through Modern Museum Fund, 2009.
Oc1936,0206.1 (hand club), gift of H. G. Beasley, 1936.
Oc1953,+.3 (hiapo)
Oc,Tah.102 (poncho)
Oc1841,0211.12 (bonnet), gift of Queen Victoria, 1841.
Oc1887,1217.1 (house model) , gift of Malietoa Laupepa, King of Samoa, 1887.
Oc1978,Q.503 (larger bamboo), and Oc.6479 (smaller), gift of J. L. Brenchley, 1870.
Oc1900.1008.1 (dala), gift of C. M. Woodford, 1900.

Index